SISTER
WENDY'S
GRAND
TOUR

*I look forward to the day when it will dawn upon
everybody that they can have odysseys and Grand Tours
and share the fruits of the world. The capacity
to see, to open up the vision of reality that
an artist offers, is innate in us all.*

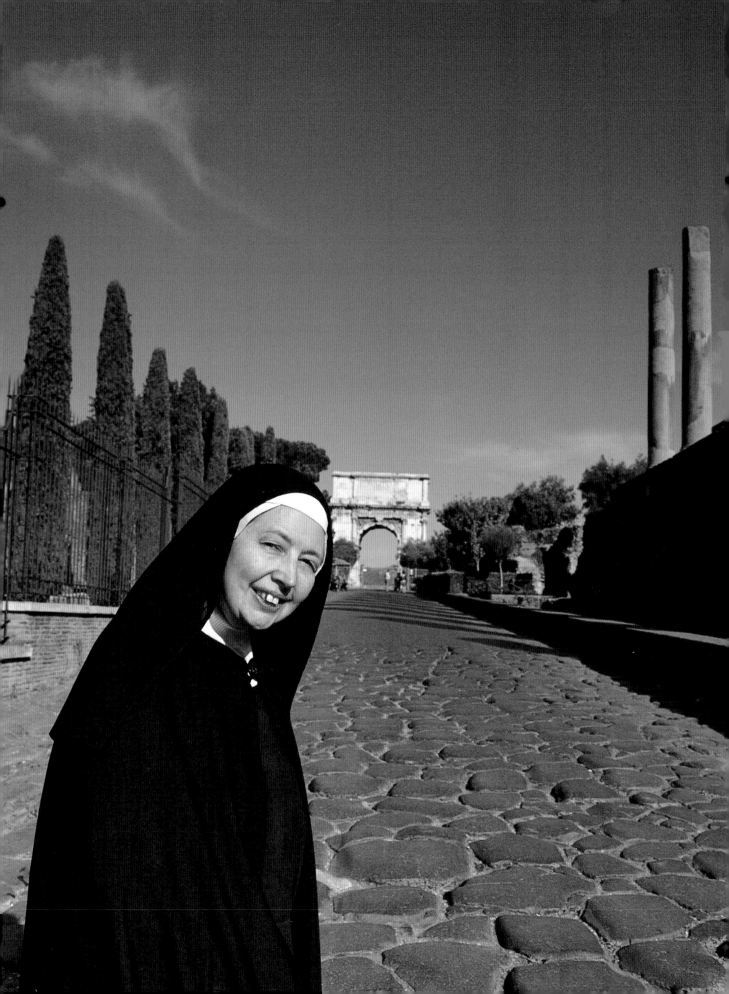

SISTER WENDY'S GRAND TOUR

*Discovering Europe's
Great Art*

SISTER WENDY BECKETT

STEWART, TABORI & CHANG
NEW YORK

© 1994 Sister Wendy Beckett

First published in 1994 for BBC Books.

This book is published to accompany the television
series entitled *Sister Wendy's Grand Tour*,
which was first broadcast in spring 1994.

Published in 1996 and distributed in the U.S. by
Stewart, Tabori and Chang, a division of U.S. Media Holdings, Inc.
575 Broadway, New York, New York 10012

Distributed in Canada by General Publishing Co. Ltd
30 Lesmill Road, Don Mills, Ontario, Canada, M3B 2T6.
Distributed in Australia and New Zealand by Peribo Pty Ltd.
58 Beaumont Road, Mount Kuring-gai, NSW 2080, Australia
Distributed in all other territories by Grantham Book Services Ltd.
Isaac Newton Way, Alma Park Industrial Estate, Grantham,
Lincolnshire NG31 9SD, England

Designed by Barbara Mercer
Illustrations by Caroline Mauduit
Photographs on pages 2 and 8 by Justin Pumfrey
Set in Bembo and Castellar by Selwood Systems, Midsomer Norton
Printed and bound in Great Britain by Butler & Tanner Ltd., Frome and London
Color separation by Radstock Reproductions Ltd., Midsomer Norton
Jacket printed by Lawrence Allen Ltd., Weston-super-Mare

ISBN: 1-55670-509-3

Library of Congess Catalog Card Number: 96-69110

10 9 8 7 6 5 4 3 2 1

CONTENTS

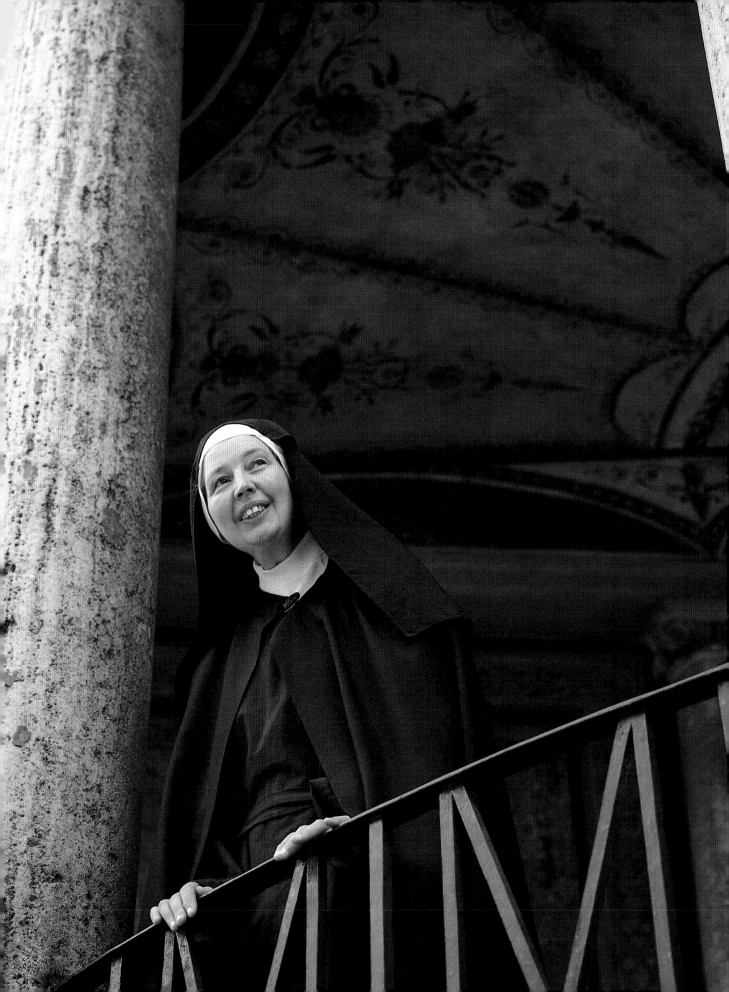

INTRODUCTION

Literally speaking, 'grand tour' means 'big journey', a French phrase because in the latter half of the eighteenth century, at the time of its flourishing, all educated people spoke French (and, if they were male, had a knowledge of Latin and often Greek). For the well-born young men setting off on their Grand Tour, it was indeed a big journey, one that would take them all around Europe and give them the opportunity to learn the nature and significance of their own cultural roots. It was a cultural search in the broadest sense. These youths were thought to be, in an age innocent of democracy, the future leaders of the country, and it was essential that they should understand their heritage as fully as possible. In practice, of course, the journey was all too often a cultural jamboree, amusement and freedom from parental discipline being the central attraction.

The young men did not venture out alone, however. The Grand Tourists travelled with an entourage, prominent among whom was the tutor, the scholarly cleric whose task it was to foster the educational purposes of the journey. The Grand Tour could – and did – last for several years, involving prolonged residence in the sites of special importance. Athens was high on this list, as indeed were Rome and the major cities of Italy, from which so much of our civilization has come. It was intended to be a serious learning process, a secular version of the pilgrimages of the religious past, and if it seemed often to fail in this, the same comment could be levelled at those very pilgrimages. Preachers in the Middle Ages were always thundering denunciations of pilgrims who appeared primarily bent on the excitements of travel, seekers of pleasure rather than grace. For the most enlightened, the two ends probably did not seem uncomplementary.

When in Rome or another artistic capital, it was a common practice to commission a self-portrait as a memorial of those happy days of youthful aspiration; even major artists such as Pompeo Batoni and Mengs made a good living on such commissions. The charming self-importance of the aristocratic young male of the eighteenth or nineteenth century is still a delight. Britain is the major centre for Canaletto studies because nearly every British visitor to Venice brought back the contemporary equivalent of an expensive picture postcard showing Canaletto's view of some stretch of the Grand Canal.

Through the kindness of the BBC, I probably travelled in greater comfort than the wealthy milord, who bumped along the rough roads of pre-industrial Europe in a lumbering

carriage, staying at flea-infested inns and encountering the hazards of a foreign menu. And, of course, I could never have gone on my own, asking the Carmelite sisters at Quidenham to pay for me, however intense my desire.

Yet, let me confess, the desire was not all that intense. The Grand Tour is essentially for the young, whose stamina is up to its surprises. Not only am I an ancient of 1930s vintage, but I have chosen a lifestyle which offers the bliss of living alone in prayer. That is a happiness so great, so humbling, that no other experience, however splendid, can compare. When kind people asked me if I was enjoying myself on my Grand Tour, I all too often found it hard to say 'yes'. I would then feel ashamed of seeming so ungrateful and, after much tactless honesty, I found the truthful answer. I would say: 'Yes, relatively.' Of itself, absolutely, I would never want to leave my solitude. But relatively, since it had become clear to me that there was a certain value for people in what I said about art, then I accepted with gratitude this great chance to see some of the most wonderful things that human beings have ever created. Now that the travelling is over, and I am back in silence again, the memories are happy ones. Sightseeing is a strain, but to have sightseen is lovely!

I did not, of course, go to 'sightsee'. There is a sense in which I hardly feel that I did visit ten different cities, as well as, briefly, Bologna, Padua and Arezzo. For I was in these enchanted places to work, to choose the art I could best share with people at home. I sometimes recalled what Matisse said of his first visit to Italy, paid for and accompanied by Leo Stein, Gertrude's elder brother. Everything they saw, Matisse complained, set Leo off, asking Matisse his opinion: 'I was only looking at art so as to talk about it.' For me, that was the condition under which I accepted my travelling privilege, and it would be ignoble of me to repine.

I must also add that my tour, though very big indeed for a sedentary solitary, was a brief affair. I did it in bursts, retiring to tranquillity in between; there were never the prolonged stays in great capitals that enabled the youthful and well-born to soak up culture by osmosis. But then, the advantage of age is that one has had years of contemplation, of savouring life, and so one knows already what one values and needs.

I did not want to consider the political structure of Europe, a vital part of the Tour-as-education, nor was I particularly keen to enjoy the cities as architecture. My sole interest was in the art. Might I have chosen differently had I had longer in each city? As all who have visited the European continent know, there is an immense wealth of art, and some cities, like Rome, are almost art incarnate. But since in each place I was able to see and discuss only five or six paintings or sculptures, I had to exclude even works I loved passionately. (I recall particularly *St Sebastian* in the Hermitage, emerging out of the smoky darkness with the pale luminosity of the late Titian, the unforgettable Leonardo *Madonnas* in the same museum, the small and haunting Perugino *St Mary Magdalene* in the Pitti Palace,

the Vermeer *Allegory of Painting* at the Kunsthistorische, the enigmatic *Portrait of a Young Man*, blue turbaned and tasselled, by the equally enigmatic Sweerts at the Reina Sofia in Madrid and the glorious glamour of Dosso Dossi's *Circe* at the Borghese.

This agonizing question of choice was eased by a decision I made at the start, that I would only deal in each country with its own national art. There were two or three countries where this resolution was very simple to keep. The Prado, for example, has all the great Spanish artists in such grandiloquent abundance that there was not the slightest desire to look elsewhere. Velázquez and Goya are among my absolute favourites. I was eager to have a good long look at Murillo, once so admired, now so disregarded, and see if I could make up my mind about his importance. There were rooms of El Greco, Zurbaran and Ribera, of the controlled forcefulness of the medieval Spaniards, so fiercely unlike the art of anywhere else. (Bermejo, for example; the severe grace of his *St Domingo of Silos* is quintessentially Spanish.)

The only problem in Italy was where not to go. I could choose only three Italian cities, so out went Siena (which contains some of the art that most enthralls me, the paintings of Duccio, Simone Martini and the Lorenzetti), Milan, with its Leonardo *Last Supper*, Naples and Bologna, so rich in my beloved Baroque art (Guercino, Guido Reni, Domenico, Pintoricchio, the Carracci), Assisi, where every artist of note in the early Renaissance seems to have paid his loving tribute to St Francis. It had to be Rome, Florence and Venice, even though that left me in the sad position of not being able to include an example of my beloved Piero della Francesca. Giotto, too, got crowded out, as did the Bellini brothers, those glorious forerunners of Titian, and a score of lesser but lovely artists like the quiet Cima da Conegliano or magical Uccello.

Amsterdam was so rich in Dutch pictures that it appears ludicrous that I made a side-trip to The Hague, but the lure of the greatest of all Vermeers, his *View of Delft*, was irresistible. Antwerp has a marvellous collection of the great Netherlandish and Flemish painters, though there may be greater individual examples in other Belgian cities: van Eyck in Ghent, or Bruegel in Brussels. In two cities I must admit to a struggle, a temptation to abandon my plan. The wealth of world art in Paris is overwhelming: the French owe a great deal to the rapacity of Napoleon and his royal predecessors. It was horrid not to attempt the *Mona Lisa* in the Louvre, though I comforted myself with the assurance that it would have been a failure. Likewise, though I am fascinated by German art, spiky with an inner Gothic passion, Berlin had at least two non-Germanic pictures I longed to include. One was Rembrandt's *Susanna Bathing* and the other was Tiepolo's *St Agatha*, the most moving illustration known to me of the wonder of faith. I have no consolation to assuage my sadness over leaving out *St Agatha*. (She has had her breasts cut off in her martyrdom, which sounds revolting, and indeed two pathetic little pieces of bosom are being borne

away by a torturer. But she transcends her agony with such total trust, looking up to where her Saviour awaits, hidden to her but more real than her dreadful sufferings. It is a wholly positive treatment of a wholly negative theme: human cruelty – but here harnessed to faith.)

Only twice did I stray from the national art of the countries I visited, but both Russia and Austria are special cases. For somebody like myself, who believes that fundamentally all people are the same, it is an abiding mystery as to why there should in practice be such divergencies. The Austrians are the most musical of races and when we stayed in Vienna I had the daily joy of going to Mass in Haydn's church. Mozart is celebrated on all sides, Strauss ripples out of every alley. But the Austrians produced little art. Even in the twentieth century, when almost every country in the world seems to have flowered into visual expression, Austria only came up with artists like Klimt, Schiele and Kokoschka, all of them pleasing artists with graphic or chromatic skills, but not of Old Master standard. So I regarded Vienna as a free city, and ranged at will through the wonderful Kunsthistorische.

Russia, too, is mysteriously bare of great artists. (Their natural genius – like Britain's – is for literature.) They had the great icon painters in the past, but then there is only salon art until the twentieth century and the glories of Malevich, Chagall, Kandinsky, Popova, Alexandra Exter and others. Since in my Grand Tour I wanted to look primarily at the past, my choices at the Hermitage were mainly of non-Russian paintings. (I did go to the Russian Museum in St Petersburg, where there are impressive works such as Natan Altman's angular and dramatic portrait of the poet *Anna Akhmatova*, or the delicious humour of Bakst's portrait of *Anna Benois*, who donated the Benois *Madonna* by Leonardo to the State. These are fine paintings but conventional: they do not expand the capacities of the viewer as do the great artists.)

Now that I have grandly toured, it all seems very dream-like. Was I really there? It is shameful to despise the bodily aspect of oneself; it is not just that we 'have' a body, which suggests that it is a tool, but that we 'are' a body, just as much as we 'are' a spirit. I hoped to be a tool for people to see through, a sort of human magnifying glass. I have been greatly touched and encouraged by the kind response to *Sister Wendy's Odyssey* in 1992, but it was a disappointment to find that people were not only interested in the art, they were also interested in me. It is the habit that does it. The veil and the cloak and the long black robe have a fascination for those who may not realize that beneath them is a rather dull woman. But if looking at, instead of merely through, the magnifying glass helps someone to see the art more truly, then it is not important. I look forward to the day when it will dawn upon everybody that they can have odysseys and Grand Tours and share the fruits of the world. The capacity to see, to open up the vision of reality that an artist offers, is innate in us all. The greatest reward I could have is to know that, despite my inadequacies, more and more people are coming to believe in their own powers of artistic appreciation.

THE PLATES

Palacio Real

Plaza Mayor

Plaza de la Villa

Prado

Puerta de Alcalá

MADRID

Although I never really expected to go anywhere, I always thought that, should the unexpected ever happen, my first choice would be Madrid. This was solely because of the Prado, that great museum that contains the supreme works of Velázquez and Goya, two of my most dearly loved artists. Now that it has actually happened and I have been to the Prado, I find my hopes more than fulfilled. There are no words to describe the experience of seeing wall after wall of Velázquez's paintings, most beautifully hung, and room after room of Goya. The Prado has the added advantage of not being too large. One can take it all in without over-exhaustion, though 'take in' are inadequate words for the impact one receives. There are wonderful El Grecos too, and a wealth of Spanish medieval art, some of it installed in a chapel so that we can understand the setting from which so many of these early works came.

The Prado does not stand alone in Madrid. An ancient hospital has been turned into the Reina Sofia museum, a triumph of modernization that keeps intact the wide, peaceful outer corridors that look down on to a sun-filled patio. The glory of the Reina Sofia, installed in a sort of sacred space of its own, is Picasso's *Guernica*, which unfortunately does not appeal to me. It is probably one of the most successful political posters ever made, but although I find its message of the evil of war magnificently illustrated for me it is not – as it is in Goya – made emotionally real.

The other great museum in Madrid houses the Thyssen-Bornemisza Collection, and I would have spent all my time there had it not been for the Prado. Although there are two superb El Grecos, all fire and surging passion, the Collection on the whole contains non-Spanish artists, and makes a lovely synthesis with the Prado. Of course, there are non-Spaniards there too, including the best-known Bosch, the *Garden of Earthly Delights*. To my amazement and distress, this was less impressive in reality than in reproduction. The colour seemed faded and the intricate detail, the great glory of this wholly inventive painting, is hard to see in the gallery. But I may only have thought this because my eyes were so dazzled from the brilliance of the Goyas around the corner!

Las Meninas (Maids of Honour)

DIEGO VELÁZQUEZ

Born Seville, Spain 1599
Died Madrid, Spain 1660

Velázquez is a deeply enigmatic man. It is very hard to know what made him tick because he gives us no clues. He is essentially secretive, never letting us in, always hiding behind his immense technique. This is not a drawback but, on the contrary, one of the reasons why he perpetually fascinates.

Las Meninas has constantly been described as the greatest painting in the world, and standing before it, overawed, I understood why this is so. But it is another matter to find the words to explain its greatness. On one level it must be the extraordinary sense it gives us of being somewhere else, there in the artist's studio on a sunny morning as he was painting the King and Queen, when the maids of honour (*las meninas*) brought in the little princess with her attendants, dwarfs and dog. Velázquez looks at all of them with his usual impartiality, giving as much weight to the squat female dwarf and the magnificent mastiff as to the little silver creature in the centre.

It is a gloriously lucid picture, in the way he has managed to show us both sides of his studio. The device of seeing the royal couple only in reflection means that the viewer is standing where they stood and, in that sense, becomes the pictorial centre. Yet the real centre is clearly the artist himself, dominating from the side, equal in status to the King, controlling the canvas, that great sweep of material that bulks so powerfully and symbolically beside him.

Everything in the picture is wonderfully imagined and painted, yet somehow the whole is more than a sum of the parts. Some of the grandeur may come from Velázquez's own psychic triumph. He was a divided man, split by two opposing desires: to be a great painter, which he visibly achieves, and to be accepted as a great nobleman, also demonstrated here by the ease of his demeanour before the King. He lived in a class-dominated society, and a painter, who by definition worked with his hands, could therefore never be a gentleman. Velázquez won this privilege by long and hard campaigning, and he wears the emblem of his victory, the cross of the Order of Santiago. (It had not yet been awarded when he painted *Las Meninas*, so he took the picture back and painted it in.)

Perhaps, in the end, the nearest we can come to explaining this picture is that we feel we are in the presence of greatness. It lifts us up out of our smallness into something bigger, which we could not have achieved by ourselves. We are ennobled, not in the trivial way the courtier Velázquez craved, but in the profound way only accessible to the artist.

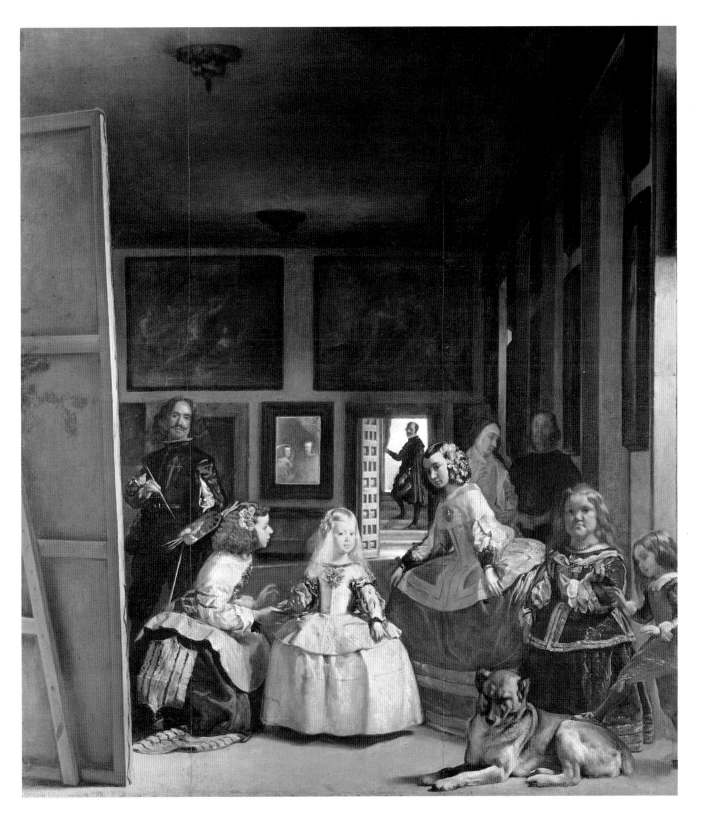

Las Meninas (Maids of Honour) **Diego Velázquez** 1656
Oil on canvas 318 × 276cm (125$\frac{1}{4}$ × 108$\frac{5}{8}$in)
Prado Museum, Madrid, Spain

Mars

DIEGO VELÁZQUEZ

Born Seville, Spain, 1599
Died Madrid, Spain 1660

This is how Velázquez sees Mars, the great god of war: deflated, dejected, stripped of his armour, completely vulnerable. This is not because he has been defeated, but because he has just suffered the great male humiliation of being laughed at. Nothing is more painful to vanity than mockery, and Mars has just been publicly made a fool of.

Mars had fallen in love with Venus, and when her husband Vulcan, god of fire, heard about it, he forged a net and threw it over the sleeping lovers. Then he summoned all the other gods to come and laugh at them. Venus was not all that upset, but Mars was deeply humiliated, and here you see him brooding over the fact that the gods all found him and his predicament highly comic.

If only we could do this to all arms-bearers, all warriors: laugh at them. It would be the end of wars, as nobody could raise the energy to fight when everybody thinks they are hilariously funny. So he slumps here, brooding and melancholy, his armour useless around him and the only thing still erect is his moustache. (A subtle touch is the pole so mysteriously poking into the picture, which we can read as we please!) His loose blue drapery also diverts me. It looks rather like a great nappy, as if to hint that men who cannot take being laughed at, especially when they are in the wrong (as Mars was in this story), are really great big babies.

Velázquez was well aware of the usual images of Mars, that heroic and undaunted muscleman of Olympus. He himself was not, by all accounts, the kind of man to whom battles had much appeal, and he may here be working off his irritation at the kind of brawny, brainless soldier who received undue adulation in the troubled seventeenth century.

Velázquez is conquering the unconquerable by the sheer power of his art. It obviously gave him satisfaction, and his pleasure communicates itself.

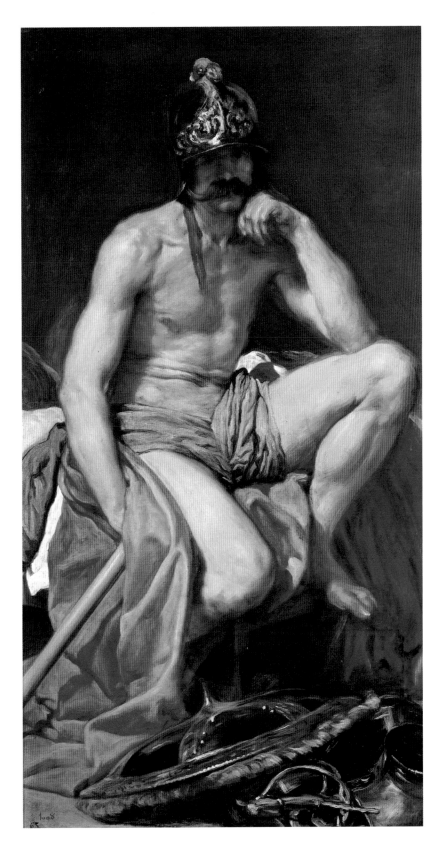

Mars **Diego Velázquez** c.1636–42
Oil on canvas 179 × 95cm (70½ × 37⅜in)
Prado Museum, Madrid, Spain

For us, Murillo is one of the great problem painters. He was no problem whatsoever for the eighteenth or even early nineteenth century: they thought he was wonderful, the greatest religious painter of all time. This was because he exactly met their religious needs. He provided something sweet and moving and tender that you could put up in your dining-room and not feel threatened or challenged by. Now, of course, that is the very thing we do not want: we want our religion hard, we want it to be in our own real world, speaking to our own real difficulties. We actively dislike any pretence that everything in the garden is rosy, knowing so painfully well that it is not. So we find it very hard to take Murillo. 'Sentimental' is the word used of him and you can see why.

This is one of the Murillos recognized as great, so it is a good test-case before which I can struggle to make up my mind, irrespective of what the general opinion may be. This painting shows us two dear little boys playing in the sunlight. One child, instead of tormenting the other, as is the habit of little boys, is giving him water to drink, which of course is conduct only to be expected: this is the Christ Child and the young John the Baptist. The pet lamb, as well as adding charm to the scene, is meant to remind us gently of what John would say later, that Christ was the lamb of God. It is a beautiful lamb, with thick fluffy fleece that you could sink your fingers into. The colour of the landscape, too, is amazingly lovely: everything is misty and indistinct, giving a sense of peace and happiness without the sharp outlines that reality so often has.

I cannot look on unmoved: it is a lovely, lyrical painting. But somehow, it does not speak to me of the truth. So when it comes down to it, despite all that I love about this picture, I have to say that the unreality counterbalances the beauty. In some ways, of course, warmth and sweetness and tenderness do exist: they are a vital part of religion and of life. But they are only a part of the whole, not the deepest part, and my reluctant decision must be: let those who love this painting be glad that they love it! But I go away dissatisfied.

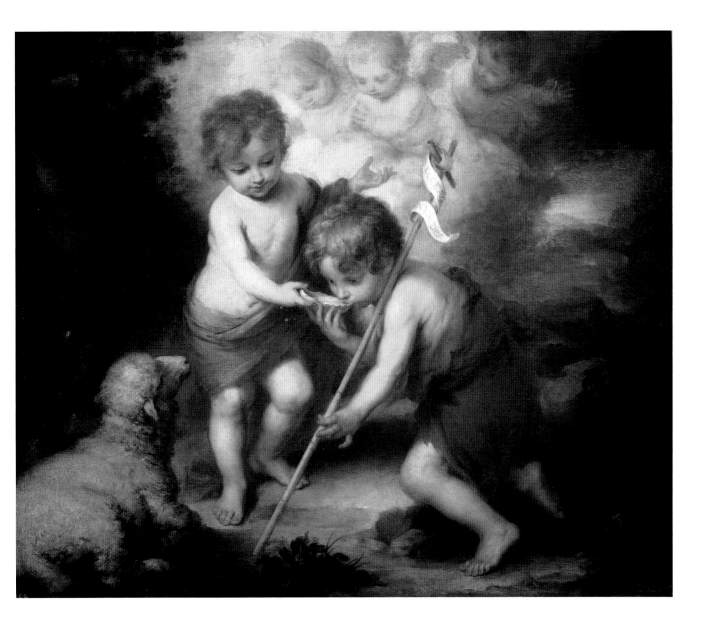

Christic Child and the Infant St John **Bartolomé Estebán Murillo** c.1675–80
Oil on canvas 104 × 124cm (41 × 48⅞in)
Prado Museum, Madrid, Spain

The young Goya had the good fortune to be commissioned by the Spanish royal family to do tapestry designs in the carefree days before the French Revolution. *The Parasol* is a carefree design: two lovers in the sunshine, smiling at us. Their bright eyes are full of the delight of being young and in love. Yet, typical of Goya, there are undercurrents, despite the physical allure.

On the girl's lap, so precisely positioned, is a little black dog, delicately hinting at the animal and erotic. The young man is behind her, relegated to the background. She looks out at us as though he were not there as a person but only as a servant, a means. Yet the actual service he is providing is to shield her from the sun, from the reality of the world. What else is behind her? A blank wall. Beautiful though she is, smiling in the sunlight and flirtatiously tilting her fan, she is a Spanish girl; no freedom lies ahead for her. She does not know it, but the young man she ignores is her gaoler. Behind him lies the whole world, there for his activity. It may seem an artificial world, but those trees fluttering in the breeze, those endless distances, all those pleasures are for him to enjoy by virtue of his masculinity. Goya gives the royal family what they want but adds his own gloss, with the lightest of touches.

Tapestry cartoons did not call forth Goya's greatest powers: portrait painting did. He is astonishingly free from preconceptions, able somehow to pierce through to an unsuspected truth. The Osunas were one of the most powerful and wealthy of the great Spanish aristocratic families. Yet he does not show us princely magnificence but a rather frightened little family clinging together. The Duke was a great grandee and highly influential, but Goya saw only a kindly, ineffectual father eager to protect his vulnerable brood. The Duchess was a leading intellectual, and having lost her first family of four children was passionately eager to be a good mother to the second family. Whatever her love, she is without a curve to her body, and her bosom is rigidly unyielding. The children are pathetic, trying so hard to be good, little round eyes fixed anxiously on the artist. Only the dog is free to play; everyone else is bearing the great weight of Osuna-hood. Goya makes no comment; he simply shows us.

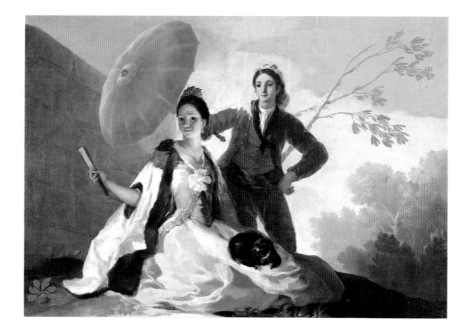

The Parasol **Francisco de Goya** 1777
Oil on canvas 99 × 150cm (39 × 59⅛in)
Prado Museum, Madrid, Spain

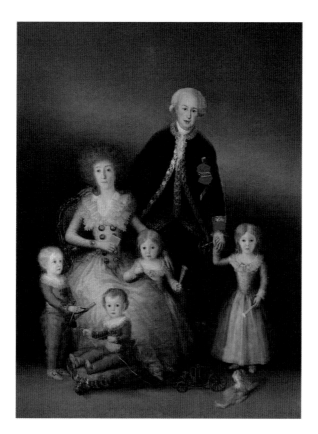

The Duke and Duchess of Osuna and their Family **Francisco de Goya** c.1788–90
Oil on canvas 225.5 × 174cm (88⅞ × 68½in)
Prado Museum, Madrid, Spain

As he grew older, Goya's artistic vision darkened, as though the horrors of the Napoleonic invasion of Spain convinced him that the sinister undertone he had always sensed in life was an objective fact. He was deeply affected by the popular uprising against the French on the second of May 1808, and the brutal executions that followed on the next day. He painted both events, the rebellion and its tragic aftermath, yet nobody ever looks twice at the first painting. It is as if revolt, uncoordinated violence, did not move him emotionally. He could plan the image but did so only intellectually. The actual shooting of the rioters, however, comes across with enormous personal force.

The *Third of May* is one of the great icons of human cruelty and human courage. (Goya may not have felt an empathy with fighting, but he did with dying.) He paints a kind of crucifixion, suggested visually by the outstretched arms of one of the victims, but he involves us not only with the killed but also with the killers. The executioners have become faceless hordes, machines for slaughter, which is what we can all become if we do not act responsibly. The victims have a terrible majesty, their faces vitally individualized and their deaths frighteningly real. They have nowhere to run to, they are trapped: corpses to one side, groups waiting for their death on the other, a great hill behind, darkness all around and the anonymous automatons in front, levelling their hedge of weaponry. Real people, in a real trap, but they at least save their individuality. The French firing squad are in a worse trap, because obedience to orders has drained them of their personhood.

The great shouting figure in the centre, refusing to die tamely, asserting his rights as a person, is an image from deep within Goya's psyche. The inexorable snare of cruelty and suffering was something he knew intimately, and his genius is to make us know it too. We are also ensnared in this picture; we cannot walk past it unaffected. The agonized faces are thrust against us, and since they are trapped, we too are trapped. We share their anguish; that is why this is one of the most terrible and moving depictions of the destructiveness and the heroism of which we are all capable.

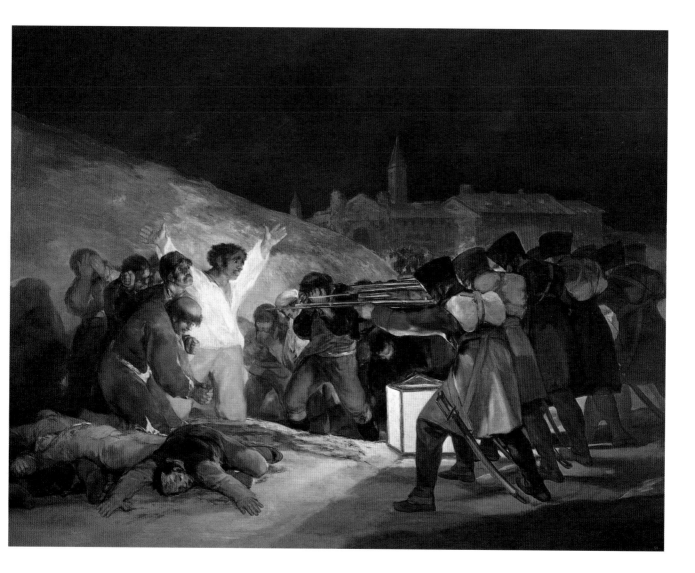

Third of May 1808 **Francisco de Goya** 1814
Oil on canvas 266 × 345cm (104$\frac{3}{4}$ × 135$\frac{7}{8}$in)
Prado Museum, Madrid, Spain

The Colossus

FRANCISCO DE GOYA

Born Fuendetodos, Spain 1746
Died Bordeaux, France 1828

Goya lived in terrible times. The Napoleonic armies invaded Spain with a great outburst of savage brutality. It seems an eerie coincidence that there was present an artist who understood more than any other the terror of war. He was shocked to his emotional depths that human cruelty seemed to have been licensed.

The Colossus shows the great panic that war brings to the innocent: all those little coloured figures fleeing away from the great giant who straddles the horizon and dominates the sky. If we ask who the Colossus is, the obvious answer is that he is Napoleon and Napoleonic fear and Napoleonic armies.

Then we look again. We see that the Colossus is not threatening the people, he is not even looking at them. Perhaps, then, this is not an attacking Colossus but a defending Colossus, the great heroic spirit of Spain fighting to the bitter end? We look closer, and notice that the Colossus does not make visual sense. Where is he? Is he rooted in the soil? Or is he standing low in a valley? Is Goya saying something deeper still: that what we fear does not really exist in material terms? The Colossus may be fear itself, the universal human dread that everyone experiences sooner or later. It may not be a specific fear: of the atomic bomb, of cancer, of Aids, but just generic fear, the fear that goes with being a creature that will one day die. It may even be a fear of life, of the burden of being an adult. But whatever the Colossus stands for, he causes panic, and both the giant and his effect have to be reckoned with.

That is the wonder of this picture, that it is not a despairing picture. In its own way, it is really a great affirmation of hope. What we experience here is Goya, old, tired, deaf, lonely, yet coming to terms with the mystery of suffering, with fear. It is his own fear that looms so hugely over him, yet he accepts it and shows us the incredible beauty of the Colossus-landscape. The people flee into nothingness, the giant menaces; Goya looks steadily at it all and in accepting, conquers. The darkness is shown as luminous, and that hard-won inner peace that Goya grasped is made available to us. If a Colossus is seen to be beautiful, it is overcome.

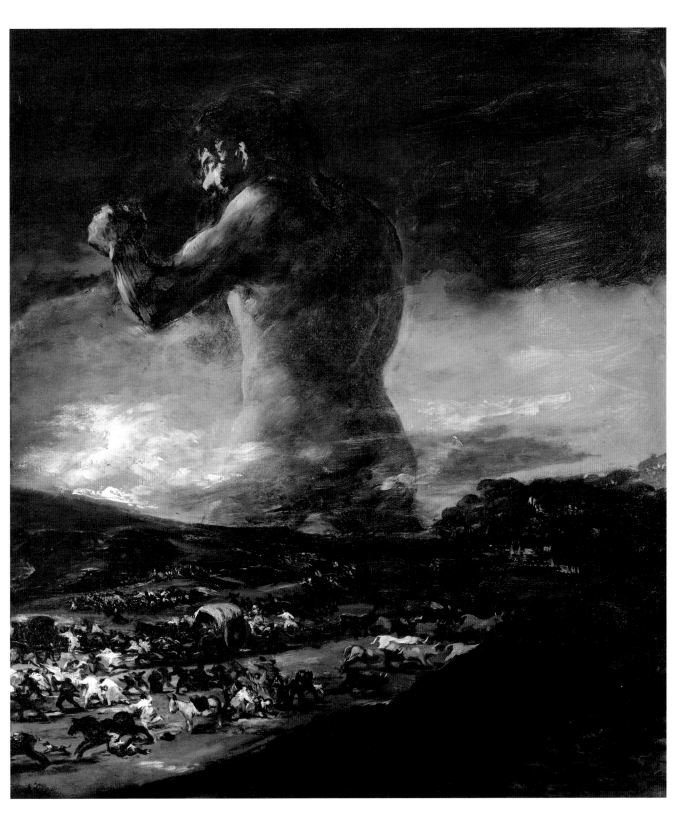

The Colossus **Francisco de Goya** c.1808
Oil on canvas 116 × 105cm (45⅝ × 41⅜in)
Prado Museum, Madrid, Spain

Santa Maria Novella

Cloister, San Lorenzo

Palazzo Vecchio

Piazza Santissima Annunziata

FLORENCE

My aim in every city was to home in on its own art, its native artists. But Florence flawed me! It was too rich, the possibilities too dazzling. I spent my time in a state of holy awe. Take for example Giotto, with whom the whole Renaissance began, a Florentine by domicile if not by birth, who possibly decorated four chapels in the Church of Santa Croce. In the wasteful manner of the over-rich artistically, Florence allowed two of them to fall into decay. But even to begin to describe the other two, the Bardi and Peruzzi, would have taken too long. Faint but visible, the great cycle of St Francis and the two St Johns remain an intense joy.

But if I linger with them, what time would I have for Masaccio? Among the glories of Florence are his great frescoes, all the more precious for the artist's early death, perhaps the greatest loss art history will ever know. His Adam and Eve are driven from the Garden of Eden and expelled into the world as we have all been expelled from the womb. Eve utters the primal scream in grief and anguish at the wrongness of life (it should not be like this; our common feeling). Her pain makes pitifully visible our common pain, but the scene is set amid such a richness of other scenes, other pains, other joys, that again it was either all or nothing. But all meant I would not have time for Leonardo.

The Uffizi has the amazing total of three works by this most magical of artists (one in collaboration with Verrocchio). The greatest of them, the *Adoration of the Magi*, remains unfinished, awesome but incomplete. It is infuriating to remember that this was the time when Leonardo was sending out job applications for the post of engineer, adding that he was also quite good as a painter. Has there ever been such prodigality of gifts? Perhaps the answer is yes, because the Uffizi also boasts the only oil painting that Michelangelo ever took the trouble to finish. This is the Doni Tondo of the *Holy Family*, which is the Sistine Chapel in miniature: same sculptural mass, same superhuman unity of form, same strange acidic colour, same nude youths in the background. Here, as in the Sistine, interpretation is strictly up for grabs. But, oh, the delight of that grabbing! Everywhere in Florence I was overwhelmed by the joy of the art; I wafted around in a sort of blissful dream, grabbing, savouring, delighting, anguishing. I longed, above all, to share my experience with all my friends.

Mary Magdalene is one of the great mythic characters that have always fascinated artists. I say 'mythic', because, although she does appear in the Gospels, we really know little about her.

There are three Marys in the Gospels and the myth-makers have made the whole story more exciting by conflating them into one. We are told that at one time she had 'seven devils', which may only mean that she had an illness, such as epilepsy. But it has been built up into this great legend of the glorious glamorous sinner who one day met absolute goodness, incarnate, and the scales fell from her eyes. This poor little creature of the slums, who had clawed her way up into being a polished and expensive call-girl, suddenly realized that her life was meaningless. She had met goodness. She saw what she was meant to be, what anybody could be if they wanted, and she wanted desperately. She was transformed overnight, threw away her silks and set herself to pray.

The legend says that she went out into the desert to live alone. She went naked, clothed only in her long golden hair, and lived there, consumed by passion. This was not the passion of remorse, regret: that is a sterile emotion, when we wish we could rewrite the past ('If only I hadn't done it!'). There is nothing sterile or negative about Donatello's Mary Magdalene. He shows us a positive passion, a burning desire for goodness, for fullness, for beauty, for total love, that passion we all have potentially though we may be too half-hearted ever to express it in full seriousness.

Donatello has carved an expression of absolute desire. He has had the wisdom to use not marble, that enduring material, but wood, that fragile organic stuff that only seems to survive by some miracle. He shows her praying, not with clasped hands as if her intensity was her own business, but with hands held delicately apart, ready to receive. In a great stance of faith she becomes resolution incarnate, totally certain that whole-hearted desire brings its own answer.

Though burnt out with longing, she is still essentially beautiful. Her bone-structure has an indestructible grace. Her face is gaunt from the desert sun, and though it is now almost fleshless, it is still exquisite, like her long slender legs and the glinting wave of her thick cloak of hair. Some of the gilt Donatello painted can still be seen, shining in the Florentine sun, reminding us of the desert and her longing. She still craves for the goodness that Donatello shows us she has already attained.

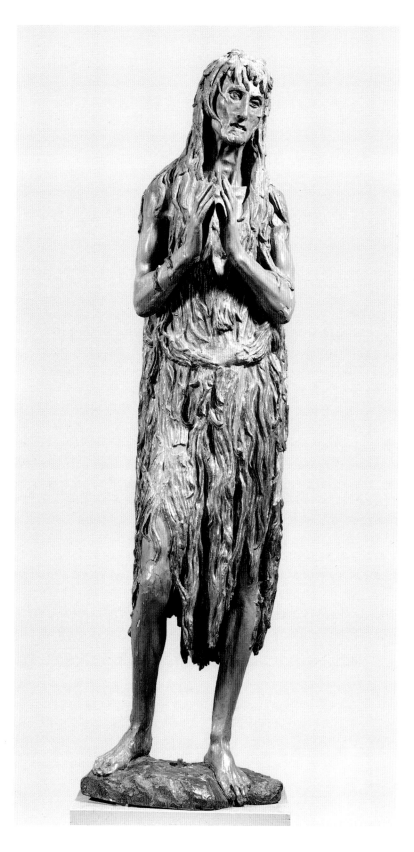

St Mary Magdalene **Donatello** c.1455–60
Wood ht 188cm (74in)
Museo dell'Opera del Duomo, Florence, Italy

Renaissance Florence was a violent and ambitious place, and I cannot believe that the monks of San Marco were untainted by this turbulence. That is what I think intellectually, but emotionally, standing where no woman was ever allowed to come, at the head of the stairs leading to the monks' private rooms, I could only think that they were free, pure, happy and untouched by their world. I feel that, solely because of the work of Fra Angelico. When we share the experience of those countless monks of the past, looking up at his *Annunciation* as they passed by, we too are taken into something so serene and pure that we feel we belong there.

In the Annunciation, the angel came from heaven to ask a creature of earth if she would become the mother of God. It is a very fraught moment, but there is nothing fraught in this painting. His Mary is almost a child, hardly bosomed at all – there is just a gentle curve to be seen. She sits on her stool without support, since life will not give this girl much support, her big apprehensive eyes fixed upon the angel, just waiting to hear what his message is so that she can obey.

The angel, so certain, so strong, so resplendent with his peacock-bright wings and pink and golden attire, is stooping humbly before this slender girl and addressing her with the greeting *Ave*. To some extent, the painting is about the word *Ave* and about silence. *Ave* literally means 'Greetings', 'Hello', but it is a solemn word, destined to be the beginning of the Ave Maria, the Hail Mary. Yet the picture is almost more about wordlessness, because we can see that both of them have their mouths closed. The *Ave* is being said from heart to heart.

The bare little cell where Mary sits is enclosed from all noise. There is a humble picket-fence and beyond it, the whole turbulence of the outside world, those rambunctious trees, that lofty mountain. Inside are the little flowers and domesticated sweetness of a place of silent prayer. Fra Angelico is reminding his brothers not to pass this scene without an *Ave*, but, even more, he is pointing out that they should go to their rooms to pray, to be silent with God, and any idle talk or occupation (the medieval equivalent of mindlessly watching television) will silence the *Ave*, drown it out. Noisiness, in words or thoughts or activities, drowns the silent sound of the heavenly greeting that comes to all of us, one way or another.

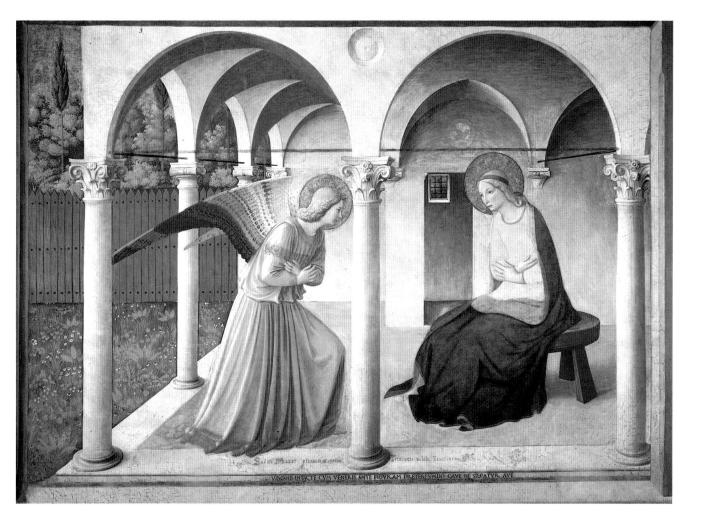

Annunciation **Fra Angelico** c.1440 or 1450
Fresco 216 × 321cm (85 × 126$\frac{3}{8}$in)
San Marco Museum, Florence, Italy

Judith and her Maidservant

ARTEMISIA GENTILESCHI

Born Rome, Italy 1593
Died Naples, Italy 1652/3

Judith with the Head of Holofernes

CRISTOFANO ALLORI

Born Florence, Italy 1577
Died Florence, Italy 1621

This is the story of Judith, the Jewish heroine who saved her people from the Assyrians. Holofernes, the Assyrian general, was besieging them; Judith stole out of the city by night, captivated him, got him drunk, and then beheaded him. In the bad old days, before women and men were fully equal, one of the great fears of any man was to meet a powerful woman who would cut him down to size. So Judith expresses the hidden fears, the pre-Freudian fantasies, of men – not now, of course, but then.

Allori shows Judith as a supremely glamorous and destructive woman; yet notice the little butterfly jewel in her hair (even the strongest woman is at heart a plaything, he hints). Her maid, the chaperone, looks on with breathless admiration, as well she might, since Judith has done a nice surgical job of her beheading. There is no mess to disfigure her. She is on the point of marching triumphantly back to her people, a heroine, but a deceiver, whose lovely looks mask an implacable will and a terrifying bloodthirst. This, powerful and beguiling as it is, is the approach of a male artist.

By great good fortune, the same gallery holds a female version of the same event, by Artemisia Gentileschi. We see at once how different it is. It is

much more practical, to begin with, and much more honest. Allori's Judith is a slim slip of a girl, the last person an innocent male would think of as homicidal. But Artemisia's is a solid young woman, with the muscle power to tackle a beheading and the sense to realize that if there is to be a decapitation, there will be blood and disorder. Allori's Judith carries the head, swinging it like an apple, no blood dripping, no preparations made. Artemisia's Judith has brought a basket, with cloths to mop up the blood, and the stains are very evident already. She has intelligently entered into the practicalities of slaughter and, as a lady, handed over the nasty thing to her maid. She is not proud of what she has done: both women are apprehensive, looking over their shoulders. Allori's Judith is fearless; Artemisia's lives in the real world, carrying her sword like a weapon, knowing that innocence is no defence.

There is an added poignancy in that Artemisia herself had suffered the indignity of rape. She also has a tendency, whenever she shows a woman vindicating her rights, to paint a self-portrait. Judith looks very like Artemisia: heavy, not pretty, but clever, alert and energetic. There is a secret personal power here that makes the story far more real to her – and to us – than it could ever have been for a male artist.

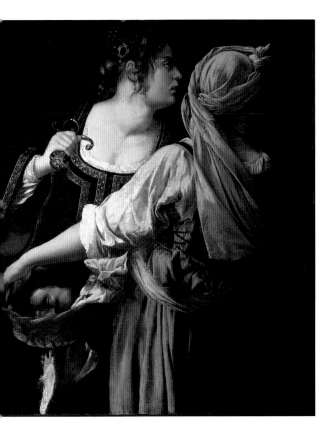

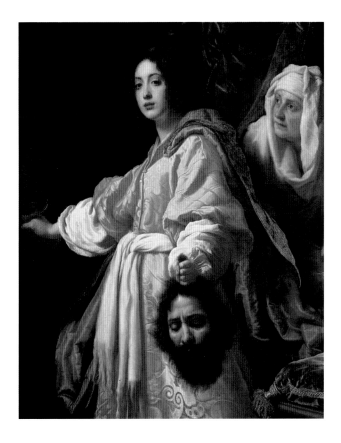

Judith and her Maidservant
Artemisia Gentileschi c.1611
Oil on canvas 116 × 93cm (45⅝ × 36⅝in)
Pitti Palace, Florence, Italy

Judith with the Head of Holofernes
Cristofano Allori c.1615
Oil on canvas 139 × 116cm (54¾ × 45⅝in)
Pitti Palace, Florence, Italy

Birth of Venus

SANDRO BOTTICELLI

Born Florence, Italy c.1445
Died Florence, Italy 1510

Some artists are realists and some are idealists, and we have no need to wonder in which camp Botticelli belongs. Although he never married, or perhaps because he never married, he always had an ideal of the perfect woman. She was both Venus and Virgin. She never changed. She was always as we see her here: tall, slender and white, delicate long fingers, exquisite face, wistful mouth, big sad eyes and cascades of long golden hair. She seems infinitely removed from the common things of life.

The *Birth of Venus* shows her borne on a scallop shell to the island of Cyprus, blown through a confetti of flowers by Zephyr and his consort wind. On the shore Humanity, a nymph, waits to receive her. That is beautiful enough, but the beauty goes far deeper because it is based on some hard, painful but necessary human truths. Venus was born out of an act of savage cruelty. The god Cronus murdered his father, Uranus, tore off his genitals and flung them into the ocean. It was from the foam that was then generated that Beauty arose. Even from the ugliest destruction and brutality, says the myth, can come Love and Beauty.

Zephyr and Chloris, the winds that blow Venus to shore, also have a relevant story. Zephyr raped Chloris, and then fell in love with her. She forgave him, and from that act of heroic forgiveness a change came over her and she became a goddess, the goddess of flowers, Flora. I think that Flora is the nymph waiting with the cloak to welcome Venus as she comes ashore; so we see Chloris twice: before her transformation through love, and after.

Venus comes naked, and this is the saddest part of the story: she is not permitted to step naked on to the land. It is a lovely world that awaits her, with all the brightness of the pebbles shining in the water, and Flora holds out a glorious cloak to wrap around her. But she does so because our world is not strong enough to receive Beauty naked. When Venus steps into our world we shall cover her up, cover her with exquisite garments, hide away from us her pure radiance. Venus is Love as well as Beauty, the two deepest human realities. T.S. Eliot wrote that human kind cannot bear very much reality. Love in its nakedness and Beauty unadorned are too much for us. We are challenged at some deep level, and Botticelli sees us as unready to face that challenge.

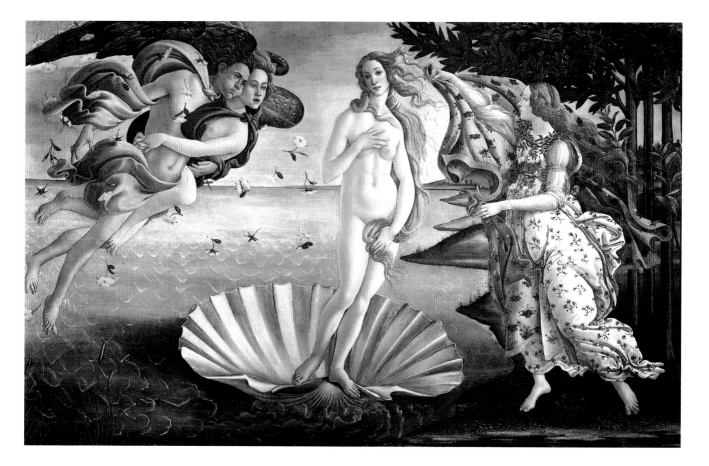

Birth of Venus **Sandro Botticelli** c.1485–90
Tempera on canvas 175.5 × 278.5cm (69$\frac{1}{8}$in × 109$\frac{5}{8}$in)
Uffizi Gallery, Florence, Italy

Primavera (Spring)

SANDRO BOTTICELLI

Born Florence, Italy c.1445
Died Florence, Italy 1510

Botticelli's *Primavera* is almost an anthology of the things we love best about him. It is one of those rare paintings you have to read from right to left, almost as if he is letting us know that love can turn things back to front.

This is a picture all about love and spring and youth and fruitfulness. Some like to read it as a sort of calender of the months from spring to summer, but I prefer to see it as two mini-dramas closely connected with love, taking place on either side of Venus. There on the far right is Zephyr, the west wind, raping the nymph Chloris. She is breathing out flowers as she turns, naked and ashamed, to confront him. But Zephyr then fell in love with her, and she turned into Flora, goddess of flowers, and Botticelli paints her again in her new dignity, radiantly fertile and life-giving. So that is one story: a husband and wife who have passed through the stage of initiation, with its struggle, pain and final flowering. When you think that this picture was probably meant for a bridal chamber, it may be that Botticelli intended some comfort to the young Florentine maiden who was going to the bed of a perhaps unknown husband. Beyond Flora, in the centre, is the benign motherly presence of a Venus

so similar to pictures of the Madonna that we can see how there was no problem for Botticelli in combining the erotic and the religious.

On the left of Venus is another threesome, surely the most wonderful thing he ever painted: the three Graces in their eternal dance. These are girls completely virginal, lost in that secret world of the young maiden in times gone by. But their timeless maidenhood is not to last. Over the head of Mother Venus flies her fat little son Cupid, and though he is blindfolded he is taking careful aim at the Grace in the middle. She is just that fraction unlike her sisters, wearing no pearls, for example, and she is the only one looking to her left, where, by chance, Mercury stands, very evidently male. He is the god of distances, the messenger god, and behind him gleams the world outside this secret grove: infinite horizons, meadows and wide fields. Botticelli is suggesting that this maiden in the middle who is on the point of falling in love must realize that love will carry her away into far pastures.

We see two stages of love: consummated on the right, just about to begin on the left, and all held between two male gods in a grove where Venus is queen. It is a supremely comforting picture.

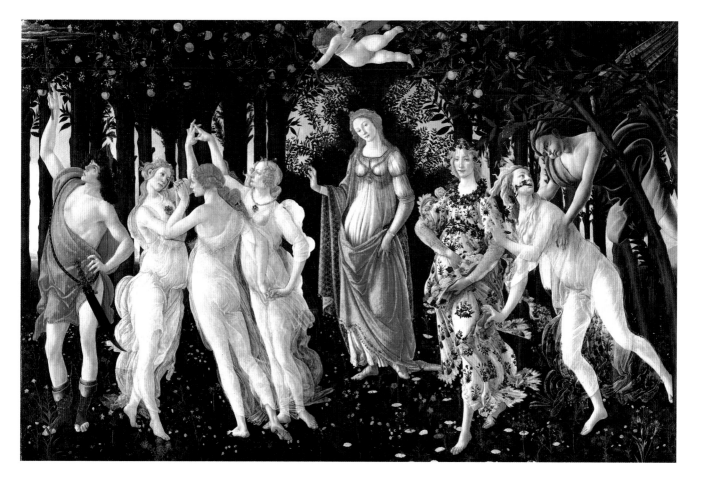

Primavera (Spring) **Sandro Botticelli** c.1478
Tempera on panel 203 × 314cm (79$\frac{7}{8}$ × 123$\frac{5}{8}$in)
Uffizi Gallery, Florence, Italy

St Peter's Square

Baldacchino

Bernini's colonnade

ROME

The simple matter of geography means that the Grand Tour cannot begin in Rome nor can it end there, yet it seems to be all about Rome. This great city has been central to all our ideas of cultural history so that it has a symbolic as well as a literal importance artistically. There is a sense of age-old creativity in its streets and squares that seems, when experienced, to be part of a personal heritage happily rediscovered. It is a city dense with art, the lived-with art of its crowded churches and old palaces. The Doria family, for example, still live in their princely *palazzo*, with a supreme Velázquez on their walls. It is not just any Velázquez, but his portrait of their ancestor, 'the Doria pope', *Innocent X*, that astounding depiction of encaged authority, which so affected Francis Bacon that it led to his series of screaming popes. *Innocent X* is far from screaming; he is rather intensely controlled, but such icy discipline, combined with the angular power of his confining chair, is very much in keeping with what Bacon intuited. (He painted his popes from reproductions, and when in Rome never ventured to see the original.)

I felt an unexpected sympathy for Bacon's attitude when I finally made the crossing from seeing pictures of the Sistine Chapel to experiencing 'the real thing'. The Chapel was jammed with eager sightseers, all buzzing excitedly to one another, and in the jostle I found it hard actually to look. The angle too: for the stiff-of-neck there is a lot of awkward craning to be done here. How wonderful Michelangelo's frescoes are only becomes clear when one has left and is thinking back. Then the strange clarity of his colour and the great sweeping majesty of his line seem so beautiful that it is almost a good thing that one could not respond fully at the time. One needs to sit down and be undistracted, and the Sistine cannot allow for this.

Rome is overwhelming in all sorts of ways. It was difficult to choose amongst its thronging centuries of art, but it seemed clear that the 'essential' Romans were Michelangelo, Raphael and Bernini. What I had forgotten, though, is how omnipresent Caravaggio is. He spent most of his wild but immensely creative life in Rome, and his energetic visions of reality seemed to meet me at every turn. Rome is a city so deeply layered with art that it was sad only to investigate one layer, Renaissance art, but one sees it in the context of the Etruscan tombs, the catacomb murals, the church mosaics and frescoes, the galleries of contemporary art. Above all, there is the magnificence of the architecture.

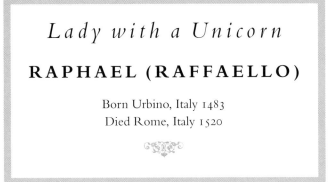

Lady with a Unicorn

RAPHAEL (RAFFAELLO)

Born Urbino, Italy 1483
Died Rome, Italy 1520

Raphael can appear rather remote in his perfection. His noble virgins with their regal children draw our deep admiration, but do we always love them? Hence my particular fondness for this work, the *Lady with the Unicorn*, because she is so accessible.

It is a charming portrait of a young girl by the young Raphael. He was a great ladies' man all his brief life (he died in his thirties), but one feels certain that there was no emotional involvement with this girl. She is a chilly little creature, with that self-contained face, pink cheeks and pale blue eyes, her neat little figure tightly girdled in and her bosom well defended. Despite her beauty and the richness of her jewels, she seems essentially unsensuous.

That, of course, is part of the meaning of the picture. She is shown holding a unicorn, and the legend held that a unicorn could only be captured by a virgin. A subsequent owner of this painting did not understand the symbolism and had the unicorn painted over with a wheel, turning the lady into St Catherine. Rescued from its overpaint, the poor unicorn looks rather bedraggled, but its presence is important. Why did the lady insist so much upon her virginal state? Had there been gossip? She certainly does not look like a loose woman: far from it. Though she may wear glorious clothes, she is very well protected, with a wall and pillars, and though the whole world is there, Raphael shows it behind her: she has turned her back upon it. This may mean no more than that, as her stiffness suggests, she has not yet been awakened: the unicorn's horn points past her, not yet towards her, firmly though she holds it. The meaning may only be that she has not seen the space at her back and the promise of love, that she is a temporary virgin. But it might also mean, despite her grandeur, that she is holding the unicorn because it is a symbol of Christ, the symbol of a consecrated chastity. It could be that she is indicating her vocational choice, that this girl wants to be a nun. It may be perpetual virginity that she seeks, a unicorn life.

Because he was a great painter, Raphael involves us emotionally, though not erotically, with this rich, beautiful but unknown young woman. He is a little daunted by her unresponsiveness, but that too he expresses in his painting. Like him, we never feel we know her, but we want to go on trying.

Lady with a Unicorn **Raphael** 1505–6
Oil on panel 65 × 51cm (25⅝ × 20⅛in)
Borghese Gallery, Rome, Italy

Rape of Proserpina

GIOVANNI LORENZO BERNINI

Born Naples, Italy 1598
Died Rome, Italy 1680

Bernini is the most dramatic of sculptors, using drama in the strict theatrical sense. Here we have a whole story encapsulated in one intense moment of overwhelming excitement.

It is the story of Pluto, the god of the Underworld, and Proserpina, an innocent nymph. She was gathering flowers in a meadow when out of a pit of darkness surged the dark god, seized her and carried her off to his underworld kingdom. No sculptured form has ever struggled more violently against the power of the brute than Proserpina. Pluto digs his hairy fingers deep into her soft flesh and she almost puts out his eye as she passionately but helplessly resists. She desperately does not want to go down to the Underworld. At one level, that is what this work is about: death, the Underworld. At any moment the young as well as the old can be snatched away. The Underworld waits beneath the meadow for us all. Yet there is a great, swinging exuberance in this sculpture that tells us it is not just about rape and death and grief; it is also about fertility.

The Greek myths survive because they deal with fundamentals; the myth of Pluto and Proserpina was their explanation for the alternation of the seasons. For six months there is death – autumn and winter – and then life rises up again and we have spring and summer. Proserpina will not stay in the Underworld; she will come back to the meadows in six months' time, bringing the spring. Amidst the rushing movement, with garment and hair flying, we are struck by the unholy glee of the god's expression: he feels he has conquered. But the Greeks knew that he had not conquered, he had merely set in order the rhythm of the seasons, and though poor Proserpina does not know it now, she will know it in the end.

We could almost say that the work is about birth. Proserpina feels she is entering into death, but she is really entering into fertility, into motherhood. In giving birth, a woman goes down into the darkness, as it were, and comes out of it with new life. Proserpina is entering upon the labour of childbearing, hence the wonderful note of hope and power that infuses the shapes. Death is life seen from another angle, something the Greeks understood poetically and that Bernini makes us understand sculpturally. His drama does not end in death; it leads to life.

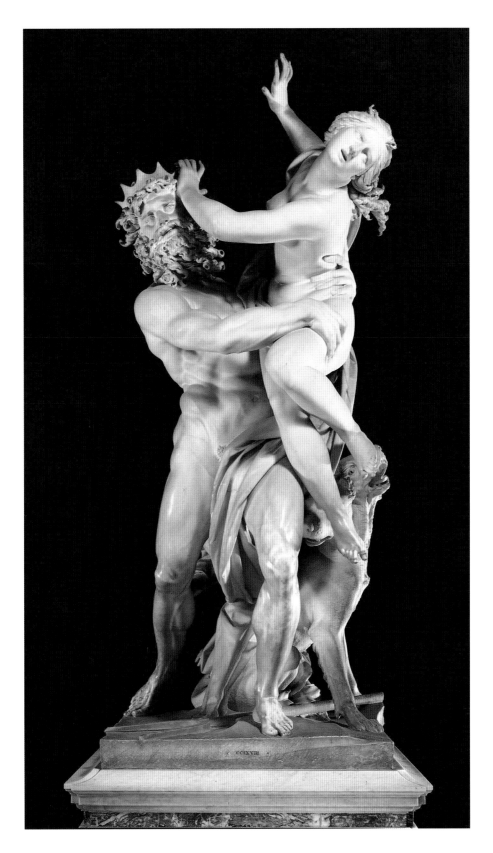

Rape of Proserpina **Giovanni Lorenzo Bernini** 1621–2
Marble ht 255cm (100$\frac{3}{8}$in)
Borghese Gallery, Rome, Italy

Apollo and Daphne

GIOVANNI LORENZO BERNINI

Born Naples, Italy 1598
Died Rome, Italy 1680

This is the Bernini sculpture that moves me most deeply. It is overpowering in its excitement and profound in its implications. If Bernini had lived today, I am sure he would have been a film maker, because he was never interested in the static but rather in the moment when things are moving and happening, the moment of the most intense emotion. The myth of Apollo and Daphne seems to have had some personal significance for him, anxious man that he was. (His self-portrait shows a thin, nervous face, pop-eyed with emotional tension.)

The Greek myths live on because they touch on things that continually matter to us. This myth is about one who loves and one who does not, who rejects. Apollo, the great sun god, fell passionately in love with Daphne, a water nymph. She fled from him; he pursued, and here we see him almost on the point of capturing her. He finds it impossible to believe that she does not want him, and he has one hand actually touching her, while Daphne, in anguish, is calling out to her father, the river god, to save her. Her face is contorted with distress because she feels her prayer has not been heard. But we see, before she does, that her father has responded: by turning her into a laurel tree. Already those delicate toes are beginning to sprout, her long slender fingers are turning into leaves, and bark is

walling her in to protect her against Apollo. We see it, and so does he. On his handsome face there is the dawning recognition that he is not going to get his heart's desire.

This myth goes deep into the human spirit. Why did Daphne flee? Was she afraid of sex? Or was she afraid of this particular lover, Apollo? Or was it power she feared, since he was god of the sun, and anyone he married came into the ambience of his glory and brightness: was she timid? Or was she afraid of God, of the divinity itself, the overpowering challenge of divine holiness? We shall never know. Bernini does not tell us her motive, he tells the strange story that is repeated throughout human history: the story of unrequited love.

The Greeks explained such love by saying that Cupid had two arrows: the golden, which caused love, and the leaden, which caused hate. But I think that is to oversimplify. Whatever it was she dreaded, she has been saved from it. Yet, in some miraculous way Bernini, who never takes disaster as an absolute, makes us feel that Apollo does get his heart's desire, though not in the way he expected. When Daphne became a laurel tree, Apollo made that his special emblem, and for ever after he wore in his curly hair a wreath of laurel. So he will have his lovely Daphne and she will have him, wreathing him, crowning him, but in the only way she can accept: platonically.

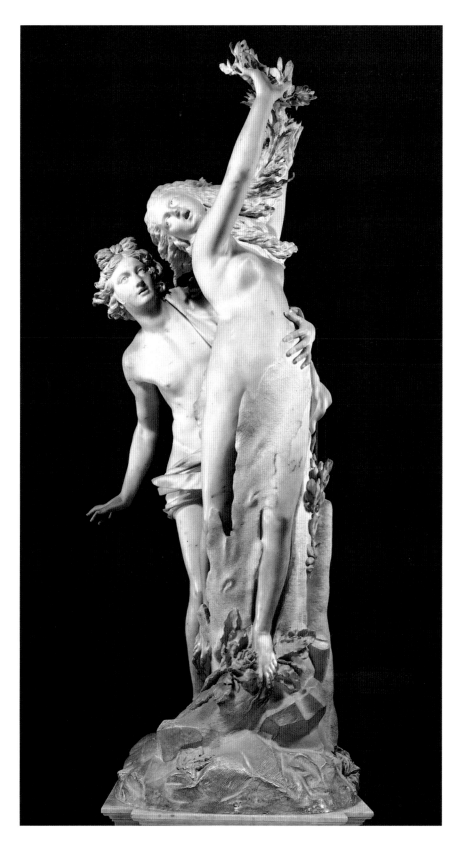

Apollo and Daphne **Giovanni Lorenzo Bernini** c.1622–3
Marble ht 243cm (95⅝in)
Borghese Gallery, Rome, Italy

Michelangelo was the great colossus of art. The Italians speak of his *terribilità*, his awesomeness, and certainly one feels awed standing before the *Pietà*, the masterwork of his youth. It floats there, serenely above us, and we feel so small and yet, also, so great, because looking at it we magnify our own selves. I am struck by the deep loneliness of those figures: Mary like a mountain, beautiful and grieving; Jesus like a great river flowing down her side. They are both isolated, the dead Jesus and the living Mary, yet they are so intimately united because they belong to one another.

Michelangelo was a lonely man, a man of enormous and tempestuous passions, who lost his mother when he was very young. He lived in a family of men: an irascible old father and squabbling brothers, and one feels that he was always unconsciously seeking for what he shows us here, this beautiful young mother. He was once asked why he had made Mary so young, and he said that she was too beautiful ever to grow old: that is the remark of a man who has lost his mother young.

I do not myself find here so much the anguish of a mother for her child but something even more universal. The Christ, so abandoned in the arms of the woman; the woman, so tenderly receptive of the power and grace of the young male she holds, both seem to me wonderful symbols of the two sides of our psyche. None of us is only male or female, we all have two sides to us: left brain and right brain, the rational intellectual, judging side, and the intuitive instinctive accepting side. We stereotype these into male and female, but the true person is a whole, both sides integrated. There is a wonderful satisfaction in seeing the two sides of the human whole come together like this, to see what it means to be united within, as Mary and Jesus, female principle and male principle, are here united.

I am not speaking theologically, and Michelangelo I am sure meant only to show the Virgin agonizing over her Divine Son, but he has transcended the normal interpretation. Mary summons us, not with her eyes which are wholly bent on Christ, but with that exquisite hand, just held out, empty, to tell us how empty life is without the fulfilment of the loved one, the other part of her own being. That silent summons is a sublime invitation to become a full human being.

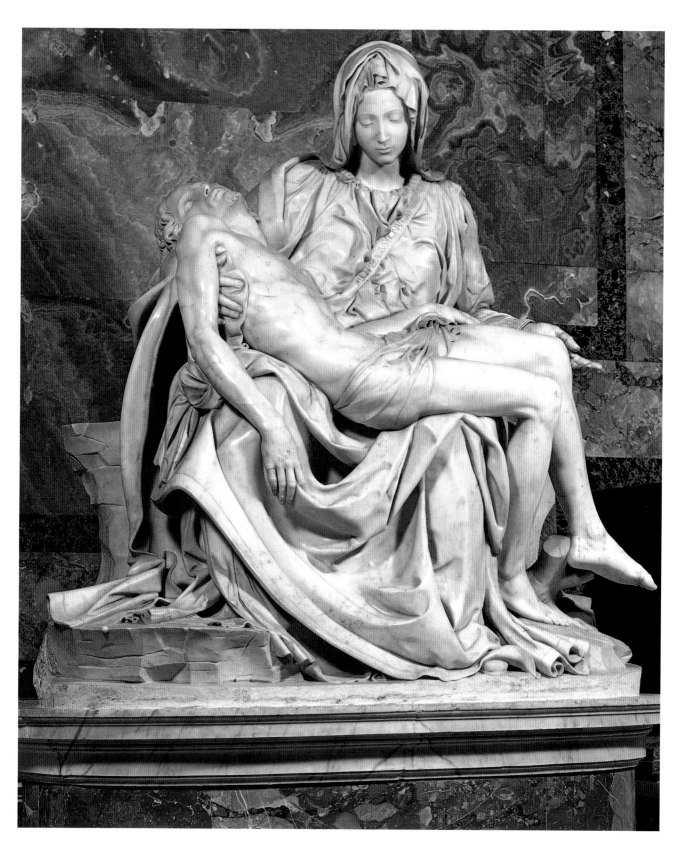

Pietà **Michelangelo** 1498–1500
Marble ht 174cm (68½in)
St Peter's, Rome, Italy

Calling of St Matthew

CARAVAGGIO

Born Caravaggio or Milan, Italy 1571/2
Died Port'Ercole, Italy 1610

Caravaggio is the great painter of light and darkness, which he understood as few artists ever have. His light shines upon the absolute solidity of the real world, and his darkness speaks – sometimes – of that other world; so we get body and soul, wonderfully conjoined.

Here he is delving into the meaning of one of the great gospel stories: how St Matthew, that comfortable, nice-looking, elderly bourgeois in the middle, was at his usual job of taking in the taxes (he was that unfortunate thing: an official tax-collector), when suddenly a summons came from Christ. He was called to leave his work and follow Him. Christ is there in the darkness, lighting up the shadows simply by his presence. That is all Matthew sees, that thin, ascetic, powerful face, and the hand, summoning. Christ is blocked from our view by the bulky figure of St Peter, representing the Church.

Caravaggio was a very canny man; he realized that most of us would not be summoned by Christ directly but through an intermediary, another person, the Church, in an ordinary way, in the midst of our ordinary lives. He had no belief in angelic visitations: a thoroughly earthly man, Caravaggio, and what makes his painting so convincing is the earthiness of it all. There is that very solid table, the great muscular legs of the men and the way the sword juts out to remind us they lived in a violent world.

What fascinated him most of all was the different responses to the summons. The two young men on the right are intrigued but uncomprehending. The one nearest Christ looks on with a kind of animal wonder; his friend, a typical Caravaggio pretty boy, has a sophisticated half-amused expression. We know at once that they will not take the slightest notice of the summons to new life. The two on the left do not even see the summons. The old man at the back, the intellectual, is wrapped up in calculations; the young man in front is material-minded, engrossed in his money.

Only one in the group understands that a new possibility has suddenly opened up, and we see him, not yet responding, but trying to accept the reality of it. He is stunned: here is a complacent career man being asked to live as a barefoot apostle. He points to himself incredulously. In a moment he is going to spring up, scatter the table, and follow Christ into the roofless darkness. It is a risk, a gamble, a dramatic version of the question put to each one of us.

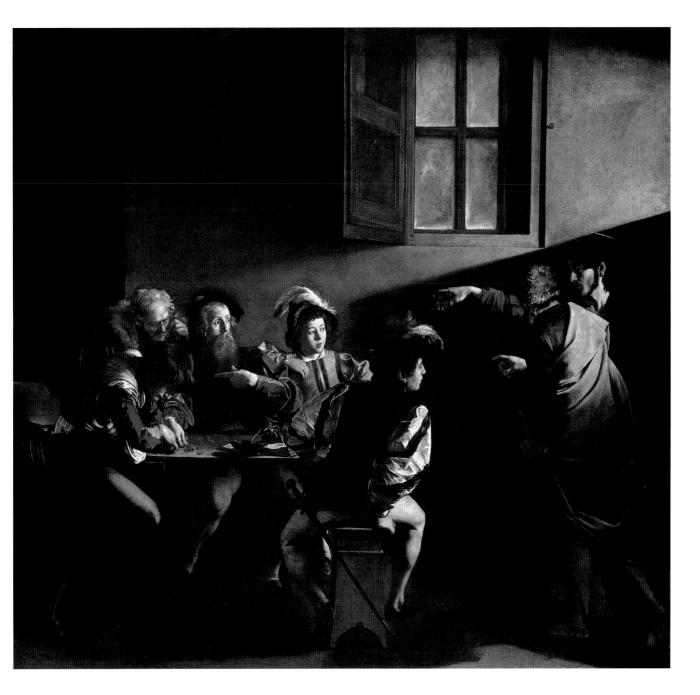

Calling of St Matthew **Caravaggio** 1599–1600
Oil on canvas 338 × 348cm (133⅛ × 137in)
San Luigi dei Francesi, Rome, Italy

This is Caravaggio's picture of the conversion of St Paul. Caravaggio is generally regarded as the 'bad boy' of art; I do not altogether agree with this. I admit he did dreadful things, such as killing somebody in an argument about tennis, but as to how responsible he was, how much freedom of choice he had, none of us can judge.

But it is that reputation, of the wild, violent, disreputable Caravaggio, that makes this picture so moving. He is showing us St Paul, who was also a kind of 'bad boy' at the beginning: a narrow, intolerant man who angrily persecuted the Christians. He was riding on a mission to intensify the persecutions when, suddenly, terrifyingly, he had a vision. Christ appeared to him. He was blinded and thrown off his horse. There is a significance here, because a man on horseback is a proud man, in control, above the others, but once thrown off his horse, all the trappings of power and dignity and self-certainty are roughly removed.

Look at Paul, absolutely vulnerable, legs outstretched, arms raised up to heaven as he falls, eyes shut since he has been blinded. Now he cannot even see what is in front of him, let alone have vision superior to anybody else. Caravaggio paints him with compassionate truthfulness, so that we see what it means to be thrown off a horse: not just coming down to the level of others, but laid flat. And Paul becomes even less important, because, with a stroke of utter brilliance, Caravaggio shows the whole event not in terms of Paul but of the horse. It is the horse who is spotlighted as central, and what is the horse doing? He is a sensitive horse, careful not to tread on the poor creature that has so unexpectedly slid beneath his belly. Paul has become lower than the beasts, the man who thought himself able to judge and condemn others. The horse is more alert to Paul's predicament than he had ever been to the needs of his fellow humans. The groom too, there at the back, is a moving figure, completely indifferent to Paul, concerned only with the well-being of his responsibility, the horse. He is tenderly leading him away, and in a minute we will be left only with Paul, with his useless sword and armour, flat on the ground, exposed to the light of truth.

One feels that Caravaggio hoped something like this would happen to him, that he would be thrown off the horse of violence and self-will that made him a misery to himself and to others, and be made to lie flat, exposed to the light of truth.

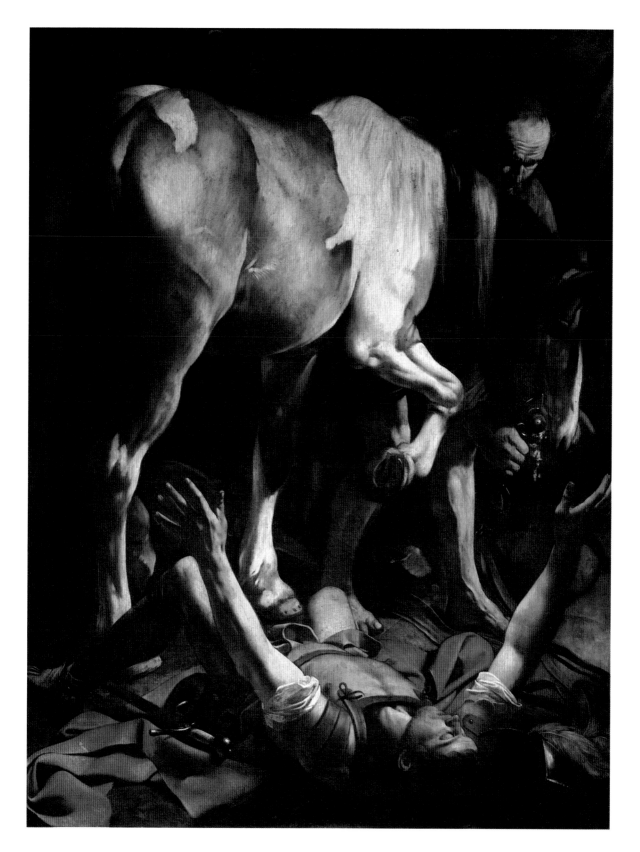

Conversion of St Paul **Caravaggio** 1600–1
Oil on canvas 230 × 175cm (90$\frac{1}{2}$ × 68$\frac{7}{8}$in)
Santa Maria del Popolo, Rome, Italy

San Marco horses

Santa Maria
della Salute

Palazzo Dario

Doge's Palace

VENICE

In the Doge's Palace in Venice, a building so splendid that it is the equal of any of the art within it, there is a grand picture by Giambattista Tiepolo that shows us how the Venetians of his time thought of their city. It is called *Venice Receiving the Tribute of the Ocean*, and it depicts Venice as a queenly beauty, relaxing with grave sweetness on her couch. On one side, Neptune and a companion sea nymph cower as suppliants, awed, holding out their riches, which Venice graciously deigns to accept. On the other side, equally cowed, lies the massive lion of St Mark, a symbol here of the Church. The commercial world of shipping and the ecclesiastical world both venerate their overlady. It is a delightful painting, none the less so for being sheer fantasy. Tiepolo was one of the last of the great Venetian artists, but he is here using his art, perhaps with a twinkle, in the service of the State. It is political propaganda at its best.

Artistically, Venice needs no propaganda: the art there is unrivalled. This is the city of Titian and Giorgione, of Carpaccio and the Bellinis, all three of them. It is still adorned with numerous great images by Veronese, who instinctively painted gospel feasts as contemporary celebrations, complete with fools, Negro pages and silk-clad musicians. (He got into trouble with the Inquisition for his *Last Supper* but solved the problem by simply changing the title to *Feast in the House of Levi*; also biblical, but less likely to frighten the timid.) The immense energy of Tintoretto adorned church after church, though some of his most colourful and exuberant pictures are now in the Accademia Gallery. I lament this. There is a wonderful Tintoretto, *Crucifixion*, in the church where I went to morning Mass (the Gesuiti), but I would have loved to have seen in its original setting the dynamic *God Creating the Animals*, all sweep and fervour, with the animals very taken aback, or his picture of *St Louis and St George*, which is really about celibacy (the modest St Louis) and marriage (St George delighting in his rescued princess as she rides the defeated dragon of lust).

We are blessed with so many fine Canalettos and Guardis in Britain, mementos of the Grand Tourists, that I saw the whole city through their loyal and crafty eyes. Perhaps the greatest tribute one can pay Venice is to say that it is even more magical than its landscape artists make it appear. Titian, who lived at a time of plague, was well aware of the darker side to his city, but it is the bright imaginings of Tiepolo that linger in my mind.

Young Man in his Study

LORENZO LOTTO

Born Venice, Italy c.1480
Died Loreto, Italy 1556/7

Lotto was a nervous, neurotic, secretive man, and perhaps that is why he could home in so well on the secrets of other people. That was what interested him; not so much the face as what was behind the face, the secret life.

Here he shows us a rich young man in his study, and he gives us plenty of hints as to what this young man was like. There at the back is his hunting horn, and behind it a window showing the land – his own land – over which he hunted. There is his musical instrument, the keys of authority, the writer's pen, the books: the young man is clearly an intellectual with other pursuits, a balanced young man.

Many artists do this, giving us a setting for the sitter, to help us get him or her in perspective. However, Lotto goes further, with that mysterious and disconnected (apparently) still life in front. There is the letter that seems just now to have fallen from the man's hand, the gold chain and the signet ring, the rose petals that lie scattered, with a 'last rose of summer' touch to them, the blue silk shawl or scarf that seems so inappropriate, and the lizard.

The lizard has been thought to be a symbol of rationality, and it may be that is its meaning here, reiterating the basic common sense of the sitter. But then we look at that brooding face and the intent dark eyes, the long and slender person of this young man and his self-awareness. He is not acting but he is aware that he is being watched. The look he is giving us, the subliminal message, indicates a much more personal sense of the lizard. The lizard is a very secretive beast, darting in and out, hiding away, mysteriously appearing and then gone again. I think that what Lotto is saying is that this youth, pondering gravely over his book, obviously concerned and wondering about life, has a secret, darting inner life that nobody is allowed to see.

In a way, Lotto sets before us the ingredients of a novel; using his visual dues we must make up our own story. He does it sober-faced, not a hint of an amused wink to the viewer. Yet, for all its gravity, we feel that the delicate melodrama, all these romantic indications, suggests that deep down Lotto found the young man rather touching in his youthful self-importance, touching and yet very vulnerable, as young people often are.

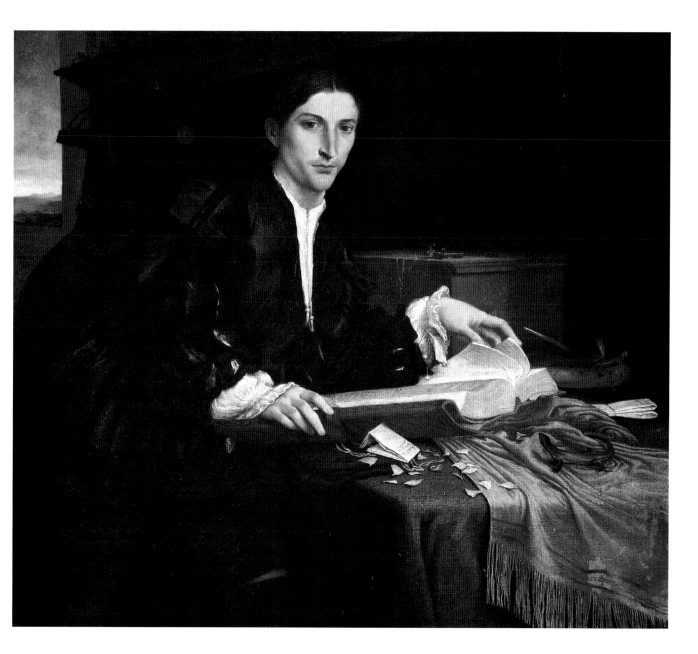

Young Man in his Study **Lorenzo Lotto** c.1527–8
Oil on canvas 98 × 111cm ($38\frac{1}{2}$ × $43\frac{3}{4}$in)
Accademia Gallery, Venice, Italy

St George is a Christian saint who also existed before Christianity. He has always been there; he is the Green Man, the hero who fights the dragon of winter, the warrior who goes down and fights the dragon of death. Human legend has always hymned this powerful myth of the hero who goes to battle on our behalf, and Carpaccio, that great story-teller, has a wonderful version of it.

St George is sheathed in gleaming black armour, riding a great and ferocious horse, and the dragon he attacks is really believable. With its pie-frill of bright scaly wings, huge teeth and enormous frame, it swirls out its dangerous tail to draw our attention to its voracious appetite. This dragon does not merely eat unprotected virgins, such as the timid little princess on the right, it destroys all in its path, vegetation as well. (Notice how the little tree in the centre, vigorous on St George's side, is withered away on the side of the dragon.)

Carpaccio is making it clear that St George is not just rescuing the lady, he is rescuing all of us. There are half-eaten bodies strewn around with gruesome realism. The saint is unhesitant; he drives his lance right through the dragon's mouth and out the other side. It is a combat between darkness and light; the air seems filled with the softness of the early morning as the creature of darkness emerges from its lair and the man of light attacks it.

What is this dragon? It is the principle of destruction, and that is not something that exists outside ourselves. We are living – unbelievably after two great and terrible wars – in a period of destruction, in the time of the dragon. It is we who destroy, either directly as in Bosnia or Iraq, or indirectly through our laziness. We have seen on our screens and in our newspapers those broken bits of bodies, the effects of war and torture. Maybe we should take a good look at the people in the distance, standing there so safely behind their balustrades and outside their churches and forts, uninterested, looking on, uninvolved in the combat. But we each have a dragon, and we each have a potential armed warrior who can spear it through.

Watching St George is not enough: we have to become the sword-wielder and tackle the dragon within. Then we can save our princess: our capacity for peace and happiness (the third participant in the story, also to be internalized), and enter into the triumph that belongs only to those who shoulder responsibility for dragonhood.

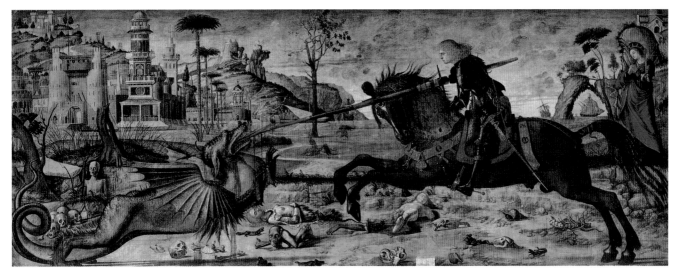

St George and the Dragon　**Vittore Carpaccio**　c. 1502–8
Oil on canvas　141 × 360cm ($55\frac{1}{2}$ × $141\frac{3}{4}$in)
Scuola di San Giorgio degli Schiavoni, Venice, Italy

When Titian painted the *Entombment*, the plague was raging in Venice. The consciousness of death must have been on everyone's mind, and perhaps specially on Titian's, because he was very old. This work was intended for the church where he was later buried and was, in fact, to be the last he ever painted; he left it unfinished.

It seems to be, in a way, his testimony to the world, this painting of the dead Christ, incandescent with soon-to-be-resurrected life, and the living Mary, so silent and contained, yet somehow so united with her son in love. There are two other central figures. One is Mary Magdalene, wild with grief, painted with enormous passion. She is fiercely angry about death, a feeling that Titian may well have shared: death is hateful, we are not meant for it. But on the other side of Christ is a very old man, coming as if in his second childhood on hands and knees. This is a self-portrait of the old Titian, affirming both his faith and his need of divine forgiveness.

Titian was a materialistic man, who made a lot of money and lived well. We know nothing about his inner life, but here, at the end, he is depicting the intensity of his yearning towards his God. As befits so personal a confession, it is a painting that glimmers between darkness and light. Everything we see seems poised to fade back again into obscurity. The tomb where Christ will lie is a grand Renaissance construction, with dimly glimpsed statues on either side and a strange, almost hallucinatory landscape setting. The haunting line of poetry by Thomas Nashe, 'Brightness falls from the air', seems weirdly appropriate. In that falling brightness we can make out two forms that express Titian's fear of death, above all death from the plague. At the right there is a strange hand reaching up out of nothing, groping for light, for help, for salvation. To make this explicit, he has painted beneath it a small *ex voto* (a painted panel put on an altar as a silent prayer). In it Titian shows himself and his son Orazio on their knees, imploring deliverance from the epidemic. But before this painting reached the church, both of them were dead – of plague.

Was his prayer unanswered, his passion wasted? At the deepest level, the answer is no, because his passion has overcome death, drawing life out of darkness and wringing hope out of despair. In the purity of its beauty alone the *Entombment* celebrates eternity, which is what painting is all about.

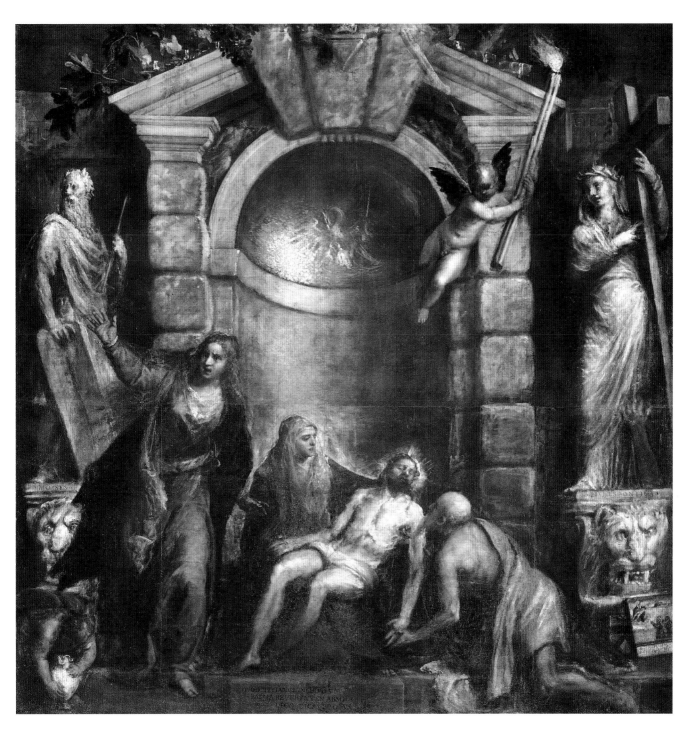

Entombment (or Pietà) **Titian** 1576
Oil on canvas 351 × 389cm (138⅛ × 153⅛in)
Accademia Gallery, Venice, Italy

The Tempest

GIORGIONE

Born Castelfranco, Italy c.1478
Died Venice, Italy 1510

Giorgione's *Tempest* is so precious, so fragile, that it has hardly ever been filmed. In one way it is nice that there are some things too vulnerable for the full glare of the camera, but in another way it is rather sad, since this is one of the most magical pictures ever painted.

Giorgione died in his early thirties, yet in that short time he brought into art something that had never been there before: a wonderful poetry, a visual music that has never been equalled. It enthralled the people of his own time and it enthrals us still. In this particular painting this is perhaps because nobody can decide what it is about. An early (sixteenth-century) description says it represents a landscape with a soldier and a gypsy. That may be literally true, but it goes a very short distance towards explaining its beauty and fascination.

Some scholars have decided that it is a picture of Mars and Venus; others have put in a claim for Adam and Eve; yet others, looking askance at the Eden theory, have emphatically disagreed: Not at all, say they; it is a symbolic representation of the Old Order, the man with the broken pillars behind him, and the New Order, the fertile woman with a city rising in the background. (A variation of this sees the pair as Synagogue and Church.) Another party vehemently urges the meaning as being a comparison between the active and contemplative life: the male being action, with his staff and working clothes, the woman being contemplation (it is true that any activity would land her in an embarrassingly unclad state). Lately the view has been growing that we should look rather at the gulf between the figures, and see the work as about man/woman, the attraction and the differences. Of all these interpretations, it is the last that I think comes closest, but for what it is worth, my own reading is quite different.

I think what intrigues Giorgione is the flash of lightning, and that this is the centre of the pictorial meaning. He is thinking of the intense darkness of night in that world before electricity or even gas. Once the sun went down, darkness came. Suddenly, through that thick night flashes a bolt of lightning, and we see. What do we see? A man and a woman, mysterious, standing there. What are they doing? Darkness closes in again: we never know. He is portraying that intense moment of vivid sight in a world of darkness, that sense of seeing and not-seeing, never understanding what is seen. He is depicting our painful human ignorance.

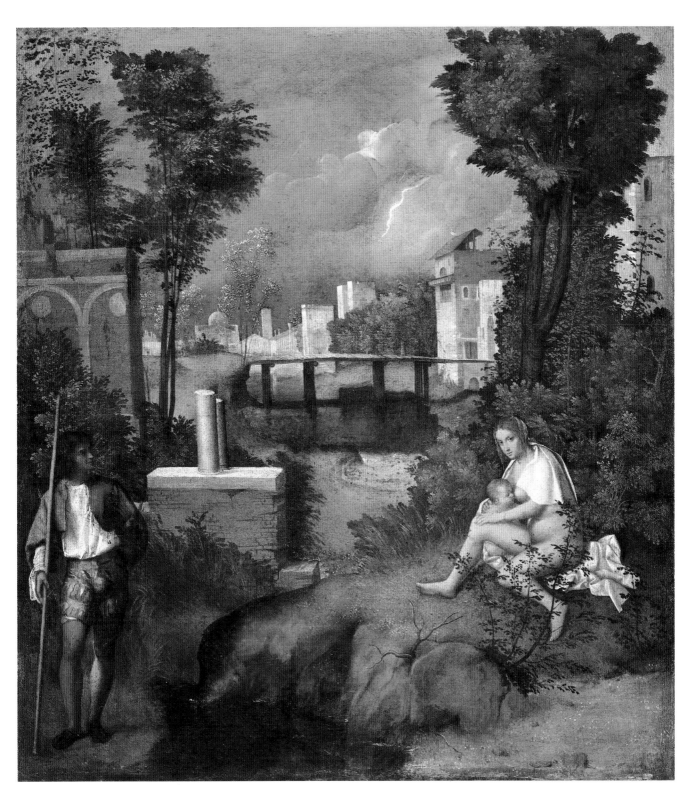

The Tempest **Giorgione** c.1506–8
Oil on canvas 82.5 × 73cm (32½ × 28¾in)
Accademia Gallery, Venice, Italy

Karlskirche

Upper Belvedere

Altes Rathaus

Piaristenkirche

VIENNA

Mozart, Haydn, Beethoven, Schubert, Strauss: Vienna is primarily a city of music. There is, of course, art there, too, but mostly in its wealth of architecture. It comes across as a rich, warm city, rather like gilded gingerbread: crisp, succulent, sweet and delightful. As far as pure art goes, Austria bloomed too late to be of great interest to me. I do indeed like Klimt, Schiele and Kokoschka, those daring early twentieth-century painters, but not enough to want to spend time on them rather than on the extraordinary riches enshrined in the Kunsthistorische, Vienna's great Old Master museum. With imperial wealth and, to be just, imperial taste, the Habsburgs managed to collect for their empire an astonishing complex of the very greatest sculptural and pictorial art. So Vienna, like St Petersburg, is a city where, by exception, I did not concentrate on the art of the country, but on the art of its museums.

I could even have limited myself to the actual fabric of the Kunsthistorische building. It is the prettiest museum imaginable. Most large museums are beautiful; I remember especially the light-filled simplicities of the Reina Sofia in Madrid and the intelligent spaciousness of the museum in Bologna, but the Viennese museum is gloriously pretty, every surface decorated with such charm and rightness that just to be there is a joy in itself. The atmosphere is fitting, too: warm and helpful, the most friendly of all the museums we went to see.

I seem to be piling up superlatives when I try to explain the quality of the collection at the Kunsthistorische. I found much pleasure in the great Giorgione *Three Philosophers*, that mysterious masterpiece with its youth, mature man and aged sage, all meditating before a dark cavern, and in Vermeer's *Artist's Studio*, otherwise known as the *Allegory of Painting*, where perhaps this most reticent of masters shows us his back as he works. Then there was the *Little Fur*, Rubens' private picture of his young wife, so private that it was never shown outside their home, never sold; so tender and adoring that we feel almost ashamed to look at such a personal expression of married love. Hélène, the young wife for whom Rubens, now an elderly but passionate husband, painted it, wanted to destroy it after his death. Fortunately it remains, a life-enhancer for all who see it, a treasure among the many treasures of this incomparable museum.

St Sebastian

ANDREA MANTEGNA

Born Isola di Carturo (now Isola Mantegna) near Padua, Italy 1430–1
Died Mantua, Italy 1506

St Sebastian was a favourite subject of Renaissance artists, but I am afraid that this was not because he was a heroic Christian martyr, rather that it was a chance to paint a glorious male nude in the full flush of youth being killed by his comrades. St Sebastian was ordered to be executed by men of his own regiment because he was a soldier who would not acknowledge the Emperor as god. He would obey him but not worship him, and that was considered treason. Here you see the result: he has been used for target practice, and although none of the archers has scored a bull's-eye through the heart, they have made an effective pincushion of him.

In *St Sebastian*, Mantegna found the perfect subject. He has been able to combine his deepest love, which was for the actuality of stone and the grandeur of Roman remains, with a profound insight into human behaviour. He is saying, implicitly, that in this stony setting, with a great cliff behind and crumbling stone and marble all around, with Sebastian's 'friends' departing along a stony road in the distance, there is nothing more stony, hard and impenetrable than the human heart.

Mantegna is also expressing his fascination with the difference between stone, the invulnerable, and flesh, which is very vulnerable. Stone shatters; flesh punctures and bleeds. But he is making this point about our vulnerability in the context of a man who is grievously wounded and yet remains upright. We cannot look at Sebastian without wincing, especially at that arrow through the face, but it is a face that looks steadfastly towards the heavens. The ropes that tie him are not all that strong or tight, and we feel that he is tied to the 'stake' mostly by his choice of principle. He is willing to die rather than give up what he believes in, which is Mantegna's other point: that you cannot destroy the human spirit. Flesh is fragile, but spirit survives. The human spirit is stronger than impenetrable marble. The pagan civilization that built the temple where he stands has crumbled away, the temple is ruined. Sebastian's human temple, his body, is likewise in ruins, but his spirit is indestructible.

With a poetry peculiar to himself, Mantegna has formed a man on a horse out of the clouds in the upper left of the painting. Very subtly, he does not show a triumphant man, since Sebastian is dying, but a bent, suffering man on a triumphant horse. The horse careers upwards: a symbol of the dying man who looks hopefully, patiently towards heaven.

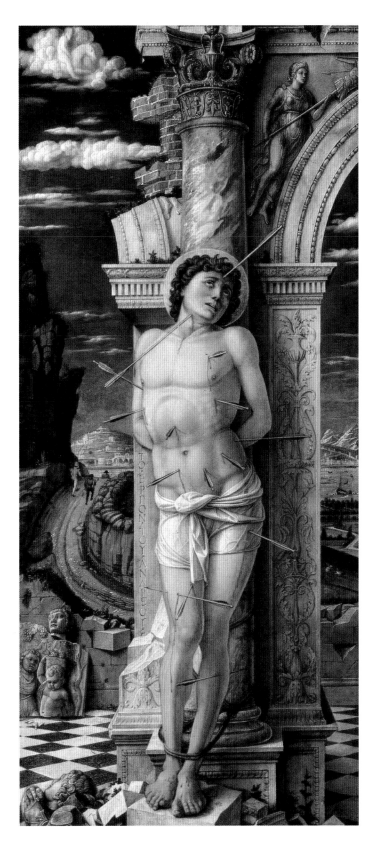

St Sebastian **Andrea Mantegna** c.1459
Tempera on panel 68 × 30cm (26¾ × 11¾in)
Kunsthistorische Museum, Vienna, Austria

When we think about Veronese we think of great, opulent pictures glowing with majestic colour. Yet the Veroneses I love most are these two small ones with their gentle autumnal hues and wistful atmosphere. They are companion pieces and deal with the same theme: doomed love, the fact that everyone, however much loved, will die.

One picture shows Venus and Adonis, which is one of the great love stories of antiquity. He was the most beautiful of youths and Venus, the most beautiful of goddesses, fell in love with him. Every man desired her, but she only desired Adonis, and as we can see, they had a period of intense, erotic bliss. He was much younger than Venus and a great sportsman, and because she was a goddess she knew that if he went hunting on one specific day he would be killed. Although she pleaded with him all night and used all her lovely wiles to keep him home, he was too young to believe that he would die, too confident of his prowess. Here we see their last time together. Venus knows this is the final embrace, but he is only impatient to be gone with his hunting dogs, off to a day's excitement. Soon his dead body will be brought back to her. Their love is doomed because, although he loves her, he does not love her enough to listen to her.

The other picture is also of a famous love story, but here the love is equal. Hercules and Deianeira were complete partners, all in all to each other, and Veronese shows us the dramatic moment when he comes back from hunting to see the centaur Nessus (half-human, half-horse) sweeping his wife away into the woods to rape her. This too is a last moment of happiness. In a second he will realize what he is seeing, fit his arrow to the bow and shoot Nessus. It should be a happy ending, but it is not. From his black heart Nessus wreaks revenge; he tells Deianeira falsely that he repents and that if she dips a cloth in his blood and makes a shirt of it for Hercules it will preserve him from harm. She believes in his repentance, but the shirt she makes is poisoned and kills Hercules, whereupon she dies of a broken heart. So here, too, love is destroyed. It is unbearable, but it is part of being human, which we must accept.

Tennyson wrote:

The woods decay, the woods decay and fall,
The vapours weep their burthen to the ground,
Man comes and tills the field and lies beneath,
And after many a summer dies the swan.

If we can make poetry out of sorrow, which is one of the things that art specifically does, then we can make it part of a fullness of being; we can use sorrow, and not be destroyed.

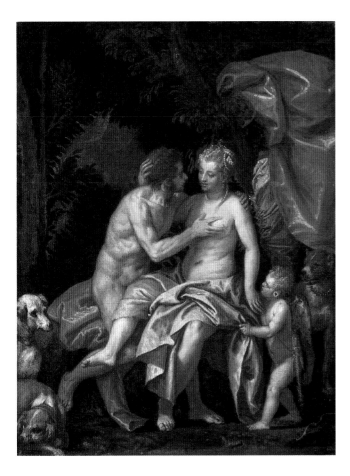

Venus and Adonis
Paolo Veronese c.1580–6
Oil on canvas 68 × 52cm (26¾ × 20½in)
Kunsthistorische Museum, Vienna, Austria

Hercules, Deianeira and Nessus
Paolo Veronese c.1580–6
Oil on canvas 68 × 52cm (26¾ × 20½in)
Kunsthistorische Museum, Vienna, Austria

Angelica and the Hermit

SIR PETER PAUL RUBENS

Born Siegen, Germany 1577
Died Antwerp, Belgium 1640

Rubens is an artist for whom I feel a special empathy, not just because I love his art, but because he himself seems to be a sort of exemplar of what human beings are meant to be: balanced and generous and good. This picture, which could so easily be seen as pornographic by a cynic, is a perfect example of why I love him.

This is an episode from Ariosto's *Orlando Furioso*, a sort of soap opera of the Renaissance, in which the heroine, Angelica, has many adventures. She has fallen into the hands of a hermit, with whom she feels wholly safe, unaware that he is not a man of God but a sad creature trapped in the wrong choice of life. He chafes against the celibacy he has vowed and is determined now at least to know sexuality from experience. So he casts Angelica into an hypnotic sleep and he is creeping up in the darkness to pull off the sheets and rape her.

It could hardly be a more unpleasant story, but Rubens is able to see it in context. He understands the tragedy of the old man who cannot live up to the vocation he has chosen, and he feels compassion for both the sinner and the sinned-against. In fact,

Ariosto reveals that nothing happened, as the hermit found himself impotent, but that is not Rubens' point. His point is that the rapist looks at the sleeping girl with an infinite tenderness and longing. He is beholding the Promised Land, the heaven that he is not yet to enter. Other men know this bliss (as Rubens himself knew it), but it is not for him.

Where all other artists who have treated this episode depict the hermit as contemptible, Rubens shows him as pathetic, as a hungering lost soul who is encountering not so much temptation as a vision of happiness. Angelica in her purity is no temptress: the human body is a thing of divine beauty. On the right we see what the viewers might expect from such a subject: Rubens has painted in a devil, lifting Angelica up on her pillow as if presenting her to the hermit. On the left, we see the truth, the bewildered, suffering man who can only respond to 'temptation' with reverence. The devil is a bogy for the childish, but it takes Rubens to realize that and make us see it too. Angelica appears to him as a vision, which is what the human body is meant to be to us: a vision of the beauty of its Creator.

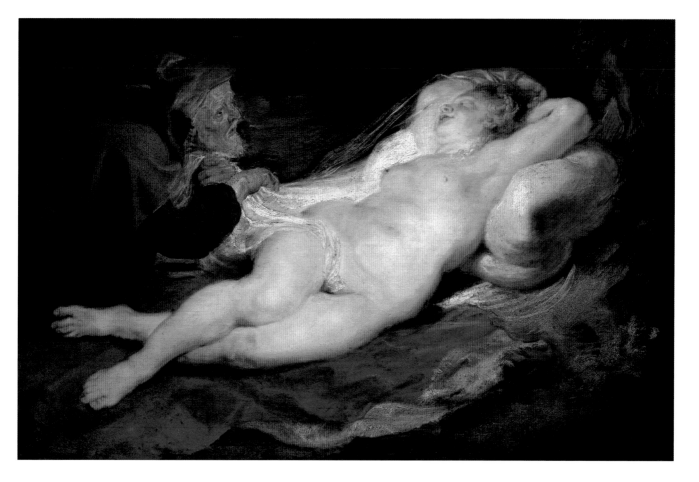

Angelica and the Hermit **Sir Peter Paul Rubens** c.1625–8
Oil on canvas 43 × 66cm (16⅞ × 26in)
Kunsthistorische Museum, Vienna, Austria

Peasant Wedding

PIETER BRUEGEL THE ELDER

Born near Bree (?), Belgium c.1525–30
Died Brussels, Belgium 1569

If I were ever arrogant enough to want to put somebody to a moral test, this is the work I would choose. At one level it is highly comic. It shows a wedding feast where practically everyone is ugly, brutish and squat, and gobbling away at the food. There is a ludicrous bride, whose fat and fatuous face is aglow with a wide beam of complacency. Yet if we see it as only comic, we have missed Bruegel's point. Great artist that he is, he keeps both levels afloat: that of the surface – the antics of the peasants; and that of the depths – the tragedy that poverty should reduce human beings to such a narrowness of life.

I get very angry when I hear talk about gluttony in this painting. The child who is scrabbling so earnestly in her bowl is not greedy but hungry, and the man with the bagpipes, who yearns with such longing towards the tray of food, is one of the most moving images in art: a hungry man. The food he hungers for, the great festival fare, what is it? Plates of porridge or custard, carried around on a trestle, exquisite only to the truly poor.

The foolish little bride is also heart-rending, so innocently thrilled to be the centre, with a paper crown hung lopsidedly above her head. One looks in vain for the bridegroom, which is part of Bruegel's theme: this is not a wedding in 'our' sense, not a marriage of lovers and friends. The pinched little man with the thin fur collar is probably the lawyer who has made this contract, which is all that it is. The bride is interested and excited by marriage itself, the ceremony, not in the man whom she may hardly know. She is in fact merely exchanging slave-toil on her father's farm for slave-toil on her husband's, except that now she will work night as well as day. Her expectations are so pitifully small, and the whole room of chewing faces is so lacking in any dimensions that make life a thing of beauty, that Bruegel clearly feels a kind of angry pity.

Commentators often wonder what the well-dressed man at the far right is doing and who he is. He represents, I think, the viewer, the educated and well-to-do who do not see their responsibility for the poor. He seems to be making his confession to a priest, which the artist must feel is the only appropriate response. That man is us: you and me.

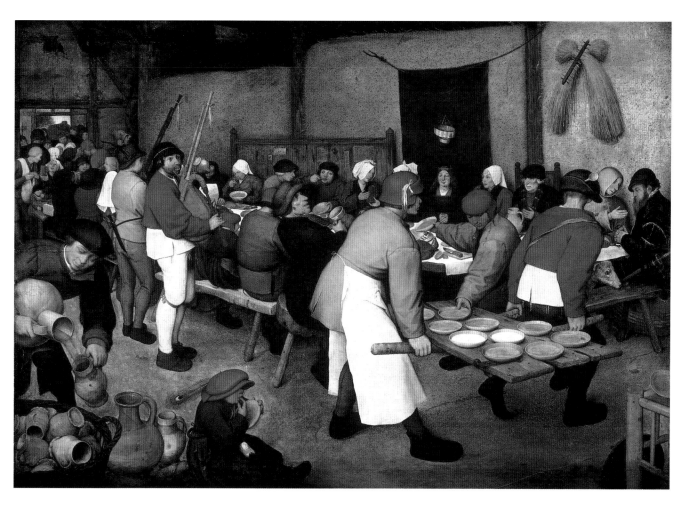

Peasant Wedding **Pieter Bruegel the Elder** 1568
Oil on panel 114 × 164cm (44$\frac{7}{8}$ × 64$\frac{1}{2}$in)
Kunsthistorische Museum, Vienna, Austria

The Assassin Suicide of Lucretia

Violante Woman in Black

Gypsy Madonna

TITIAN (TIZIANO VECELLIO)

Born Pieve di Cadore, Italy c.1487
Died Venice, Italy 1576

These five Titians are on a wall together, each superb in itself but even more wonderful together, because the museum has seen how they balance and complement one another.

At either end is one of Titian's great dramatic pieces. In *The Assassin* (or *The Bravo*) we see a beautiful, carefree youth at a party, crowned with vineleaves. Suddenly an enemy confronts him, someone from his past, who grabs him by the neck, concealing the dagger. This is Nemesis, arising unexpectedly to haunt and take vengeance. The young man reaches immediately for his sword, so there is a hint that he has a guilty conscience and that it is indeed the past come back to exact its toll.

The fear and violence are echoed by the marvellous *Lucretia* at the other end. She was the chaste wife who was raped by Tarquin, son of the king of Rome, and who could not live with the dishonour: in the morning she killed herself. Here again, the past, memory, has returned. The dark head behind her own is not there in reality but in consciousness. Tarquin has physically gone, but Titian is reminding us that for a raped woman, the rapist has never 'gone'. The foul intrusion into a personal sanctuary remains; a memory that causes Lucretia to take up the dagger and stab herself, just as some secret (in this case never to be revealed) has caused the assassin to take up the dagger against the fair youth at the banquet.

Equally dramatic – perhaps for some people even more dramatic – are the two magnificent blondes on either side, where we can feel Titian's physical excitement at the wonder of radiantly fair hair and the way it contrasts with the gorgeousness of their clothes. The girl who wears black seems to do so specifically to make her white skin gleam so whitely and her fair hair shine with such brilliance. Both girls were probably courtesans, but they know their own worth: these are superior ladies of the night whom Titian depicts with great dignity. Even more dazzling is *Violante*, so called because she has a violet tucked into her bodice. She used to be called *La Bella Gatta*, 'the lovely cat', because (I say this as a cat-lover) there is something so feline about her self-possession, her sleek beauty. No woman in art is less of a modest violet than this lovely creature, with the almost canary yellow of her hair so triumphantly played off against the deep blue of her gown. It is a completely modest gown, as is the woman in black's, but the long, slow under-the-eyelids glance is wholly challenging.

Then, in the middle, there is the *Gypsy Madonna*.

It is the only one of the five that is still, silent; it has a quiet centre, without excitement. Yet there is an inner dynamism that makes it perhaps the most exciting of the five. It is known as the *Gypsy Madonna* because Titian's model for Mary is a dark, countrified girl. Against her arm stands her superbly insouciant little son; both of them are lost in some reverie. Behind her swarthy beauty hangs an exotic curtain or carpet, with the rich deep colours that Titian paints so beautifully. But even more lovely is the landscape on the left, so misty and luminous, so suggestive of the immensities we sense around us. In that mysterious background there is a solitary tree, and, under it, a solitary young man, sitting alone, not showing us his face. Could this perhaps be the young Titian?

The Assassin
Titian c.1515–20
Oil on canvas 77 × 66.5cm (30⅜ × 26⅛in)
Kunsthistorische Museum, Vienna, Austria

Suicide of Lucretia
Titian c.1515
Oil on canvas 82.5 × 68.5cm (32½ × 27in)
Kunsthistorische Museum, Vienna, Austria

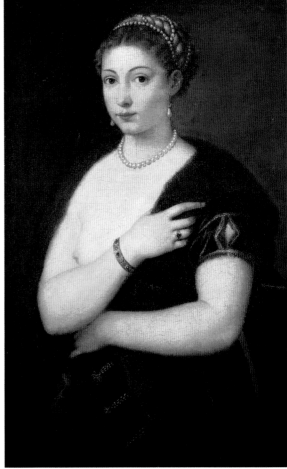

Violante
Titian c.1515–18
Panel 64.5 × 51cm (25⅜ × 20in)
Kunsthistorische Museum, Vienna, Austria

Woman in Black
Titian c.1520
Oil on canvas 59.5 × 44.5cm (23⅜ × 17½in)
Kunsthistorische Museum, Vienna, Austria

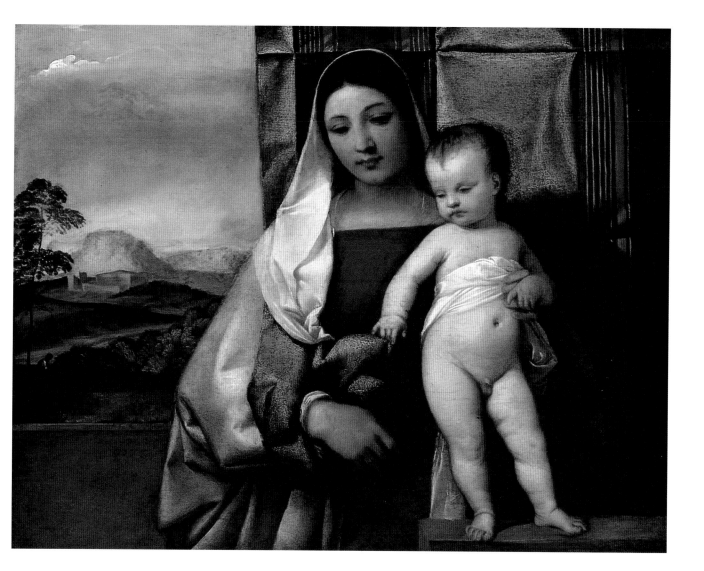

Gypsy Madonna **Titian** C.1510
Panel 66 × 83.5cm ($25\frac{7}{8}$ × $32\frac{7}{8}$in)
Kunsthistorische Museum, Vienna, Austria

Palace Square

Hermitage

Ballroom

Stroganov Palace

Pavilion, Pavlovsk

Kikin Palace

Pavlovsk

ST PETERSBURG

The only city I was reluctant to visit was St Petersburg. I was eager, of course, to see the art, but I was apprehensive that it would be viewed in a dank and depressing atmosphere. These foolish expectations were immediately confounded. The gentle good manners of the people, their touching hopefulness and courage, all this seemed to shine through the spacious and shabby magnificence of St Petersburg's streets and noble buildings.

The Hermitage itself is perhaps even more splendid than the art it enshrines. It is not the only museum that was formerly a palace (think of the Louvre, for example), but it is unique in maintaining its palatial identity. Crystal chandeliers flash their rainbow colours to the marble walls, and we walk dazzled through corridors of splendour: gigantic malachite urns to the right, immense Sèvres vases to the left, mosaics to the front, damask and gilt to the rear. All this cherished magnificence leads one through and on into the actual galleries, themselves resplendent.

To take merely one example: with true Russian largess, the Hermitage boasts not one Leonardo but two – the very beautiful, if icily regal, *Madonna Litta*, and the enchanting Benois *Madonna*, which was the first authenticated commission Leonardo received. It was lost for centuries but turned up mysteriously in the nineteenth century in the centre of Russia. It has all the rough power of early genius: a plain little Mary, wholly engrossed in the miracle of her baby. He is examining, with infant absorption, a flower. It forms a cross, but neither are aware of anything except the fascination of watching. Almost always, artists show the Madonna as aware of spectators, sharing her prayerful worship with them. Leonardo sees her as completely human and private, a delightful child, and in this very simplicity, a most moving icon.

I dwell on this picture because it saves me from the daunting task of trying to describe the wealth of this museum, its hall of Rembrandts, room of major Poussins bordered by a room of Claudes, with Rubens around the corner. From the Director himself to the guards, we were given a gracious welcome.

You could take this picture anywhere in the world, to the deserts, jungles or islands, and everybody would immediately understand it and respond.

This is a picture about parental love, and we have all either had a loving father or longed to have one. The story is the gospel parable about the father who had two sons. The younger was unwilling to wait until his father died and asked for his inheritance in advance. The father gave it, and the son went off and wasted it. Then there was a famine, and the son found he had only fair-weather friends. He kept alive by working on a pig farm, so hungry that he envied the pigs their swill. He came to his senses, remembering how even the servants at home were well fed and housed, and he decided to go back. He composed a little speech confessing that he had been a rotten son, and asking only to be treated as a servant.

Now we come to what I think is the loveliest part of the story. We are told that when he was a long way off, his father saw him coming and ran out to meet him. It is as if the old man, knowing his son's weakness and that he would one day return

penniless, had gone out every day to watch for him. When they embraced, the son tried to stammer out his speech of repentance, but the father would not let him. He simply held him tight and rejoiced, summoning the servants to bring out the best garments and to kill the fatted calf, because the true father offers total love, always.

Rembrandt shows them lost in a silent intimacy, the son's face half-hidden, his poor, worn-out shoes falling from his calloused feet, his clothes ragged, his exhaustion palpable. The father's cloak swells out in almost womb-like protection, enclosing them in that one-to-oneness that is the essence of all relationships and cannot be judged by anyone else. The elder son looms judgementally at the side, resentful, as stiff as his staff, a man of legal narrowness instead of love. He receives no embrace because he does not seek it, standing aloof from the family and the extended family of servants, all-eyes in the background.

This parable may have had a special poignancy for Rembrandt, all of whose children died young, except for one son, Titus, and even he died before his father.

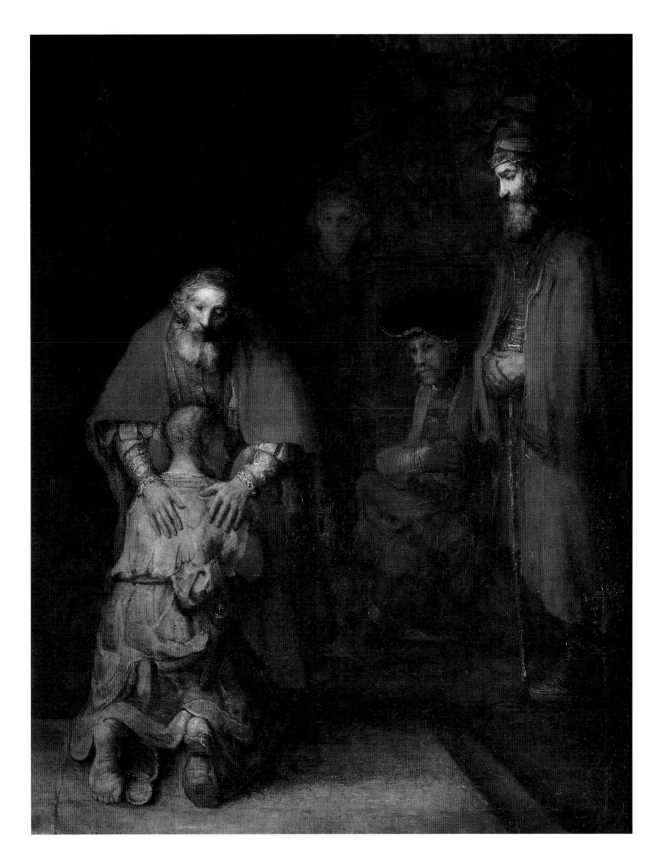

Return of the Prodigal Son **Rembrandt** c.1662?
Oil on canvas 262 × 205cm ($103\frac{1}{8} × 80\frac{3}{4}$in)
Hermitage Museum, St Petersburg, Russia

Portrait of a Lady

CORREGGIO (ANTONIO ALLEGRI)

Born Correggio near Modena, Italy c.1489
Died Correggio, Italy 1534

Correggio's *Portrait of a Lady* fascinated me, not, I confess, because of her beauty, though it is indeed an extremely beautiful painting, but because of her expression. It would be unkind to call it smug, but she has an air of ineffable self-possession, as if she knows something and vaunts it. There is almost an element of split personality, too, with her hair so tightly compressed, the obsessive perfection of the twisted braids of headgear and the cascades of flowing sleeve. There is a great expanse of bosom, but so modest, so tightly nipped in, and while she wears the golden chain of luxury and success, under her gown peeps the coarse knotted rope of the Franciscans, an Order vowed to poverty.

Sometimes in art we need to practise detective skills, and here the first clue is given by the silver bowl she carries. On it is an inscription in Greek, taken from that part of Homer's *Odyssey* where Helen is mixing a magic potion that makes people forget their sorrows. It is a phrase often applied to art; music, poetry and painting lift us out of the grief of our limited lives and take us into something greater. There is a hint, then, that this woman may perhaps have some connection with the arts. This is confirmed when we look at the tree that shades her. On it grows ivy, symbol of immortality, and there we see the laurel, sign of Apollo, god of song. Might the chain then be not merely a personal adornment but the gold chain given to the triumphant artist?

There were two women in Correggio's life who meet these conditions, but one I dismiss because he described her in a letter as 'the most beautiful woman' he had ever seen, and this lady, seductive though she is, has rather a long nose. But the other candidate, Veronica Gambara, was not only a poet of renown but was closely associated with the Franciscans. So now we see her secretive smile differently. Poets live in two dimensions, that of the imagination and that of the earth, and the secret they know is that of creativity. But we notice that she is offering the silver potion for us to share.

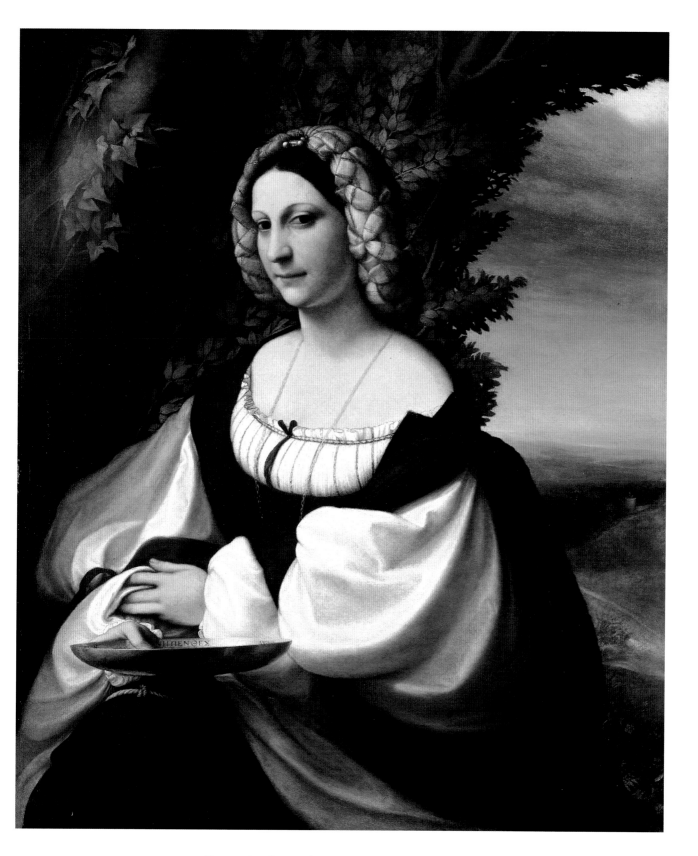

Portrait of a Lady **Correggio** c.1519
Oil on canvas 103 × 87.5cm (40½ × 34½in)
Hermitage Museum, St Petersburg, Russia

Poussin has a disciplined poetry that I find irresistible. Here his subject is an episode from Tasso's epic poem about the First Crusade, *Jerusalem Delivered*, in which the Saracens have captured Jerusalem and the Christians are fighting to get it back. Needless to say, the issue is basically political, rather than religious.

Tancred was the great Christian hero, not only because he was such a wonderful fighter but also because he was the ideal knight: gentle, courteous and thoughtful. At some stage in his adventures he met a Saracen lady called Erminia, whom he treated with his usual, calm thoughtfulness, and she fell irrevocably in love. It was a doomed love, because of the difference in politics and religion, the war between their peoples, geographical separateness and the sad fact that Tancred hardly knew that she existed. However, Erminia too had adventures, was captured, escaped, and was found by Tancred's squire, Vafrino, who promised to take her to his lord for protection.

With beating heart, Erminia travelled through the night with the squire, and as dawn broke they came to the city, where they found two dead knights. One was a Saracen, and with a cry of incredulous horror, she recognized that the other was Tancred: they had come too late.

Erminia knelt down beside him, says Tasso, and whispered: 'Though gone, though dead, I love thee still; behold/ Death wounds but kills not love,' and she wept. Her tears fell on his face and he opened his eyes. Tancred was not dead, but dying. They wrenched off his armour, those great plates of steel; he was dying of loss of blood, and they had no bandages. Erminia seized his sword and cut off her hair – the crowning beauty of every woman of that time – and bound his wounds. Then his troops appeared, and the story has a blissful ending. We can foresee this ending, I think, because of the horses. The warrior's dark steed stands motionless, obedient, passively waiting. But Erminia has a horse of active power, lovely, intelligent, his flowing mane and tail rather like her own hair, as keen as she is to see if love will bring the dead back to life.

It is a story about hardness and softness, the gleaming metal and the vulnerable girl. Only when the armour is taken off can he be healed. This life-out-of-death theme, showing that love is stronger than war, is symbolized in the lower right corner where there is rough stone, but from the stone grow flowers.

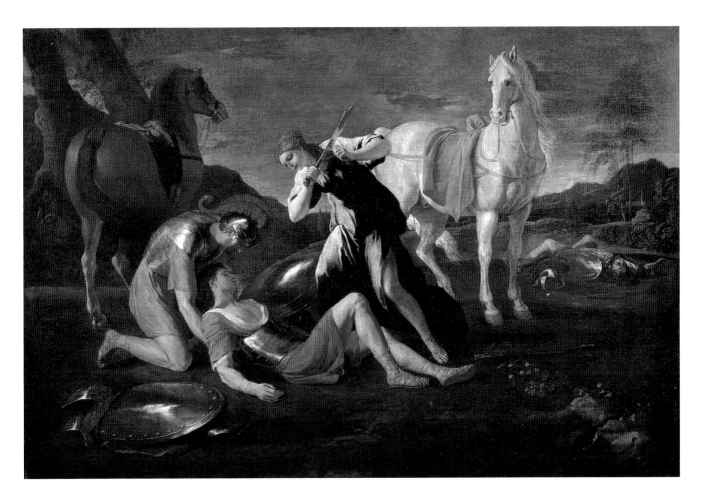

Tancred and Erminia **Nicolas Poussin** 1630s
Oil on canvas 98.5 × 146.5cm ($38\frac{3}{4} \times 57\frac{5}{8}$in)
Hermitage Museum, St Petersburg, Russia

For many artists the sheer size of the Hermitage and its halls is a fearsome challenge. But Rubens responds to challenges and faces up to them with superb verve and insight. This picture celebrates the mythological marriage of Ceres, the goddess of earth, and Neptune, the god of the waters. She comes with all her fruitfulness and flowering, and he meets her with his trident, his waves and a triton blowing a conch. Above them, Hymen, the god of marriage, holds a wreath: Water already wears his crown, and now it is Earth's turn. We are shown the human body at its most magnificent; Neptune is great, bronzed and muscular, his hand reaching out to Ceres, who is pale, opulent and gleaming.

It is in the union of these hands that we see the unique Rubens insight, his deep understanding of the meaning of love, of married love above all. Their hands are clasped, the clasp of friends, with that genuine and lasting liking that gives reality to a lifelong partnership. Earth and Water look deep into each other's eyes with a sweet and unaffected trustfulness. She is giving herself fully, 'marrying' him by her very look, and so is he.

But this giving, this profound friendship, is not a mild affair. Earth has brought to the marriage her tiger (not a very good tiger, which I suspect was painted by one of Rubens' pupils). The tiger of passion has to be brought into the relationship, but it is a domesticated tiger. Neptune's equivalent is probably the wild triton, subdued into ecstatic horn-blowing, serving his lord's cause. Rubens reverences human sexuality, that divine gift. Neptune's trident is a phallic symbol, the openness of the conch has female connotations, and in the centre is a large open jar, a womb symbol, pouring forth its fullness while the *putti* below remind us that marriage normally leads to children.

Rubens was a man whose own marriages were absolutely happy. After the death of his beloved first wife, he grieved sincerely and then married again with equal joy. He understood that the union of earth and water gives us clay, and that it was from clay that God fashioned the human race: that from clay comes creativity.

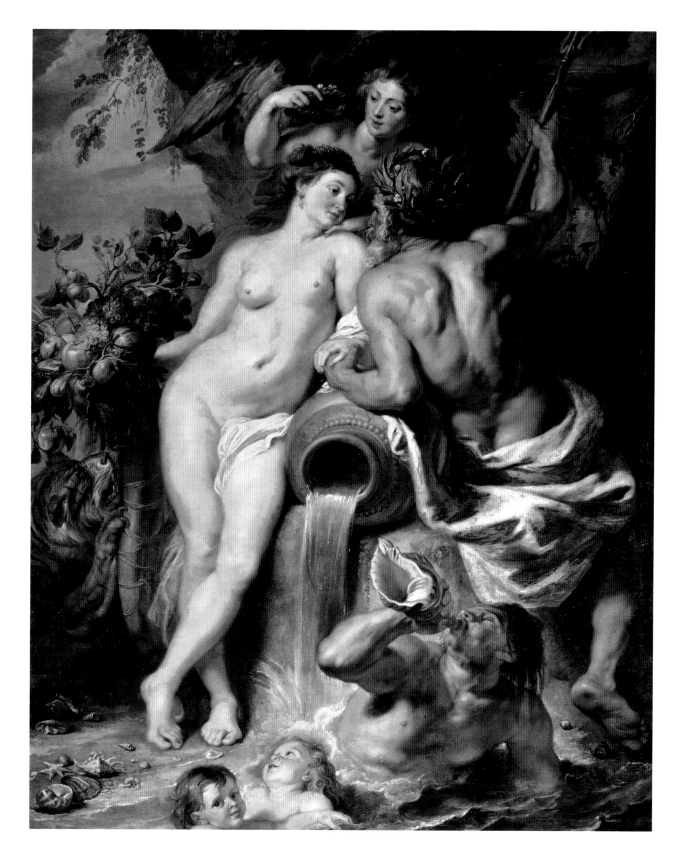

Union of Earth and Water **Sir Peter Paul Rubens** c.1618
Oil on canvas 222.5 × 180.5cm (87$\frac{5}{8}$ × 71in)
Hermitage Museum, St Petersburg, Russia

Apostles Peter and Paul

EL GRECO (DOMENIKOS THEOTOKOPOULOS)

Born Candia (now Iraklion), Crete c.1541
Died Toledo, Spain 1614

This is just the kind of picture that gets ignored in a big gallery. It is not one of the great flamboyant El Grecos and in any large museum we see hundreds of saints, so there is a real danger that we shall do no more than mentally register the artist's name (El Greco: typical elongation) and pass on. But if we linger long enough really to look at it, we see that the painter is not interested in Peter and Paul and generic 'saints', but that his interest is much more complex and demanding.

At one level, El Greco is interested in the human difference between these two men. Paul is the intellectual, the man of fire; he is all activity, all passion, all power. One hand is thrust with great emotion on to a page of scripture, tense with the desire to make us understand. The other hand is equally tense, one finger jabbing outwards like the sword of the spirit that he preached, lit up as brightly as is his unprotected head. That wide brow suggests his intellectual sharpness, and the large pointed ears remind us that the preacher needs above all to listen.

The pictorial centre is the two hands that make such a contrast: Paul's pale and vehement, Peter's the brown hands of a working man. One brown hand is tranquilly folded in on itself, at peace; the other holds the keys of authority, but unobtrusively, the fingers holding the wards and only the circle of the open handle visible to us. Peter is the man of peace, the man of prayer, his face humbly hidden in his greying hair. But El Greco shows the two bodies forming one block: they need each other, they complement each other. It is this mutual dependence that gives them their balance.

El Greco is saying something profound. In each of us, there should be a union between the decision-making part, with its passion and energy, and the loving, quiet part of us. It is the wise and gentle part that keeps the active, choosing part from making the wrong choices. It is the Peter and Paul in our own psyches that El Greco paints, and it is important that, at the back, there is a broad beam of light, the open door. The picture invites us to go through the door, and the more we look, the wider that door seems to open.

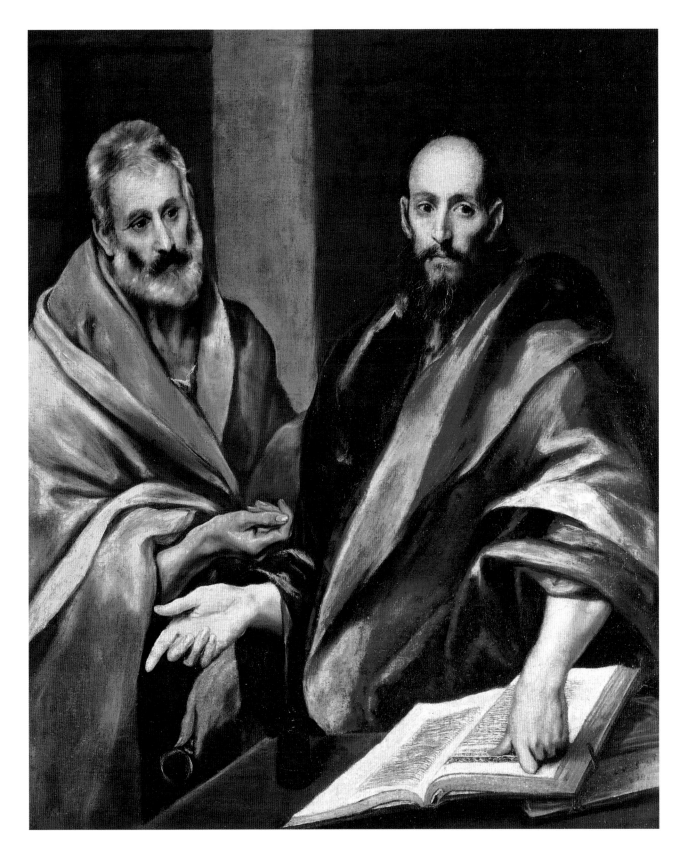

Apostles Peter and Paul **El Greco** c.1587−92
Oil on canvas 121.5 × 105cm (47⅞ × 41⅜in)
Hermitage Museum, St Petersburg, Russia

Composition VI

VASSILY KANDINSKY

Born Moscow, Russia 1866
Died Neuilly-sur-Seine, France 1944

Apart from the icon painters, the Russians had no artist of genius until the twentieth century, when there was an enormous and dramatic flowering. My favourite among these painters is Kandinsky, although I hesitate to speak about him because he is essentially an abstract artist and that is a kind of painting that many people find difficult. But, if you let some of his early figurative work allay your distrust, you may be persuaded to share my delight in this large work that lights up the attic in the Hermitage, where it hangs with a select group of Kandinskys, of which this is my clear favourite.

At this stage of his life (1913), he usually based his abstraction on some actual scene. The great explosions of colour and the air of controlled violence tempt me to risk guessing what I think the subject is: a battle at sea. At the left there seem to be two ships colliding, oars waving wildly, and there is another form like a ship in the centre, gliding down beneath the huge curve of the wave above it. The bright diagonals may suggest cannon-shot,

shown graphically, and to the side may be masts or oars or lances, with a Roman battle standard on the upper left. This is a classical sea battle from the past, but is as wild and confused as the battles of any age.

I am not insisting on my interpretation, but it is obvious that we are watching a scene of violence. Kandinsky is not trying to represent literally, say, a ship or a storm. What he is trying to do is to give us the feeling of what such an experience might be like. He is using colour and form to express emotion. This is really rather a dark picture, with the lowest centre very black and ominous, and closed and sinister shapes shutting in the centre, yet it is an exhilarating work because the explosion is so marvellously controlled; remember, its title is *Composition VI*. After the Revolution, the authorities were dismissive of this kind of painting, as being beyond the understanding of the workers. But I think they underestimated the ordinary capacity to understand; they had a sadly elitist approach.

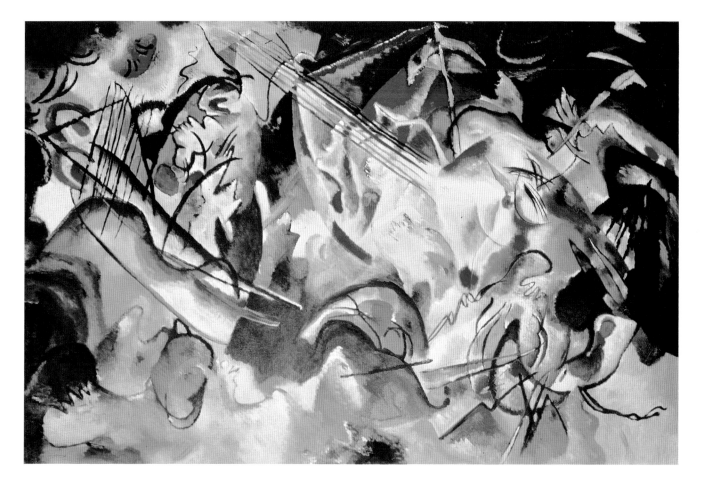

Composition VI **Vassily Kandinsky** 1913
Oil on canvas 195 × 300cm (76¾ × 118⅛in)
Hermitage Museum, St Petersburg, Russia

Schloss Charlottenburg

Volkspark, Friedrichshain

Brandenburg Gate

Gendarmenmarkt

Nikolaiviertel

Neue Wache

BERLIN

Berlin is not the most romantic of German cities but it is one of the most exciting, and in this it reflects something of Germanic art. It is an uneasy excitement, though, and the split that was symbolized by the Wall runs deep through the psyche of the art.

It seemed oddly fitting that the Gemälde Gallery, the great Old Master collection, should be housed in a building that is modern on the outside and traditional on the inside. This is in no sense a criticism. There are tremendous works in the gallery, from every age and country. I especially rejoiced in the medieval and Renaissance sculpture (which is not actually in the Gemälde Gallery but in another section of the parent Dahlem Museum). I lingered lovingly over a serene Riemenschneider carving of *St Crispin*, the shoemaker saint, calmly bent over his last, with a wilderness of heels and soles tucked under the bench.

In the gallery hangs my favourite painting of *St John the Baptist*, by Geertgen tot Sint Hans, where a bearded John sits rather glumly in a forest clearing, twiddling his largish toes. It is a grief to me that I missed the cities that are richest in Piero della Francesca, but Berlin offered compensation: a deeply silent *St Jerome*, where the intentness of the saint's concentration is paralleled by Piero's concentration on the geometric trees and their gleaming reflection in the little stream that winds gently through the grasses.

Berlin also holds the picture that moves me more deeply than any other: Tiepolo's *St Agatha*. He is all too often considered a brilliant lightweight, but no painting so marvellously expresses the depth of faith than this one. It has a wall to itself in an upper room, a quietly contained explosion of pain sublimated by a trust in the meaning of what is happening.

I would have loved to have talked at length about this and other works, but I wanted to dwell only on German art, with its contradictions, its graphic energy, its uncanny sense of the pagan forest united, by a sort of wild control, with a muscular, philosophical vigour. It is uniquely exciting, like Berlin itself.

The uncanny power of German art is seen at its deepest and most characteristic in Germany's greatest artist, Dürer. This is a portrait he painted two years before he died, a superb depiction of his friend Hieronymus Holzschuher, one of the most influential men in Augsburg, a major politician and wealthy aristocrat. Holzschuher could only have become a friend of an artist because Dürer had built up the status of his profession and laid a proud claim to its human significance.

What makes this portrait both so great and so Germanic is that Dürer is interested not only in what Holzschuher looked like but also in what he actually was like. He sought not the facts alone but the truth behind them. We get an impression of an entire and distinctive personality. It was a family portrait, cherished for generations by his descendants (which explains the perfect state of preservation: the Holzschuher family kept it covered by a protective panel). The sitter clearly had precisely this strong prow of a nose, a firm yet kindly mouth and eyes of a pale brilliance. But look at the hair. Look at the almost obsessive perfection with which those hairs snake round his head, electric with vitality yet so intensely controlled.

Dürer makes us aware of two qualities: great power and great discipline. He subtly contrasts the fox fur around his neck, the dead fur of the animal, with the bristle of his beard, the live fur of the man. Everything in this picture is functional. Beneath the outer garment we glimpse the straight line of a white shirt, one short tab of material, as if Holzschuher is even controlling his underwear. We experience within him a double source of power: the casual, passive power of the rich nobleman and the dynamic wilful power of the skilled politician. These two powers almost make him seem a force of nature.

No setting is provided. Dürer almost skewers him to the panel, undefended, because he needs no protection. Dürer sees his friend as transcending his context. He sets him against an indeterminate blotchy blue, so that we can be free to encounter him and respond. We can meet his gaze, despite its force. In showing the potential of this one man, Dürer enables us to become aware of our own personal potential.

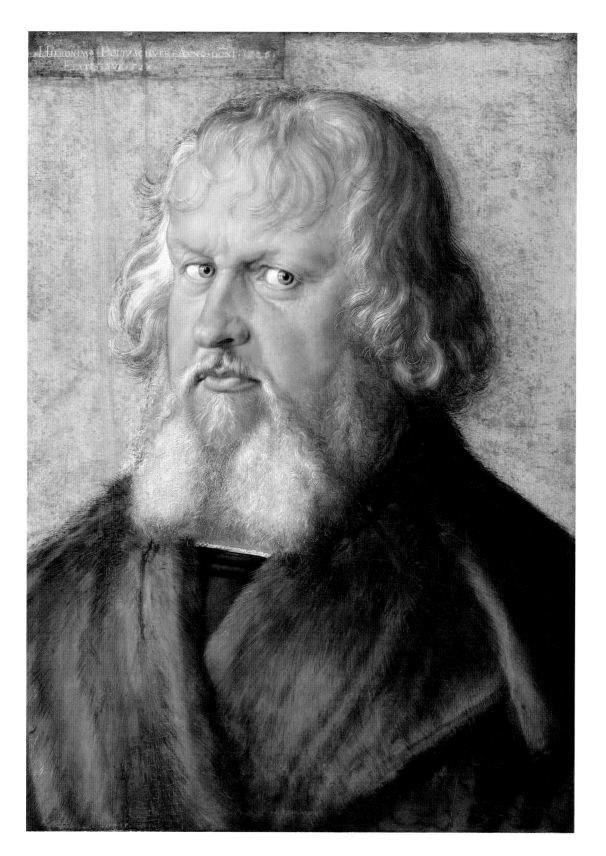

Hieronymus Holzschuher **Albrecht Dürer** 1526
Oil on panel 51 × 37cm (20⅛ × 14½in)
Gemälde Gallery, Dahlem Museum, Berlin, Germany

Holbein is not a typical German artist: without disrespect we could call him 'a German who got away'. He went to Switzerland as a teenager and then moved on to England, later becoming Court Painter to Henry VIII. Holbein's work, so smoothly perfect, is in many ways more international than national. He does not have the German interest in inwardness. What concerns him is not the nature of Gisze's deepest self but the nature of his personal world. We are, as it were, going through the keyhole and being asked to guess what kind of man he is.

It is not a difficult question. There are many clues, not least a placard giving his name and age: he is thirty-four. There is even an envelope addressed to him at the Steelyard in London, so we know he is a Hanseatic merchant, with the tools of his trade all around him in his neat, green office. We can see the weighing machines, the books, the boxes, the seals, the ledgers, the petty cash, all he needs for his correspondence. His sleeves, with their cascade of glittering satin, tell us that he is a wealthy young merchant. On his desk is a wonderful, exotic rug and a fine Venetian glass vase.

The carnations add a more intimate note, because they were the flowers of betrothal, which suggests that this portrait was intended for Christine Kruger, to whom we know he was engaged. He may be anxious to impress her – on one wall is his motto: 'No pleasure unearned.' She is getting a serious, responsible, successful young man for her husband, and a meticulous one. The lovely hanging ball is a pomander, filled with scented petals to sweeten the air, and the gold clock reminds us of the need to be thrifty with our time.

It is by no means an impersonal portrait, but Holbein does not go too close. He respects Gisze's privacy. Even more, he protects him by cocooning him in the sanctuary of his office, walled away from what might have been a sense of loneliness, here in an alien land, far from his home, perhaps a little pressured and needing the familiar certainties of his private workspace. We warm to good, serious, lonely young Georg, and we may share this happy sense of the protective enclosure that Holbein offers with his wonderful understanding of the ordinary.

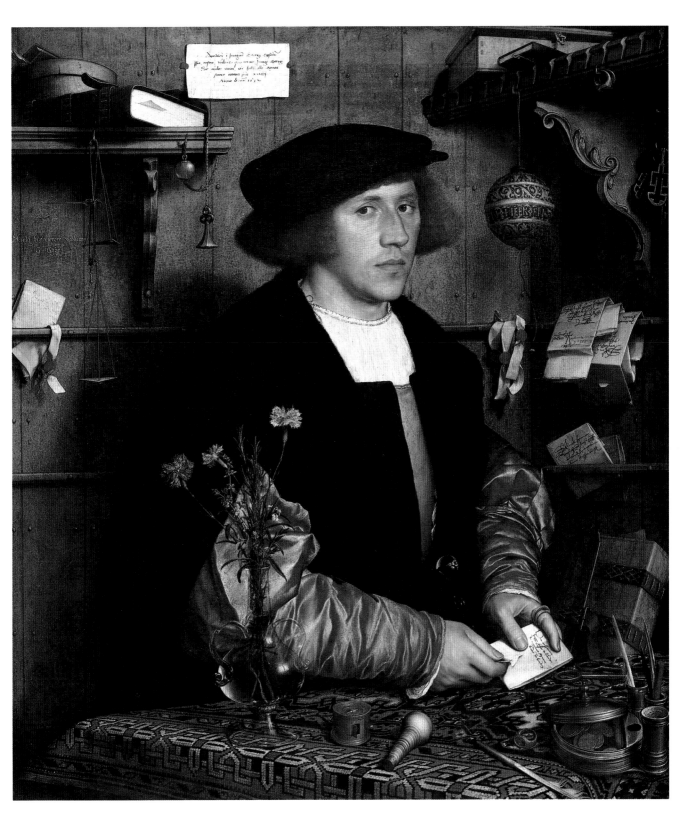

Georg Gisze **Hans Holbein the Younger** 1532
Oil and tempera on panel 96 × 86cm (37⅞ × 33¾in)
Gemälde Gallery, Dahlem Museum, Berlin, Germany

Hans Baldung was a pupil of Dürer; a weird man with an obsessive interest in witchcraft. In his work we always seem to feel the Teutonic forests and hear the wind whistling through the trees while ghosts and witches mutter in the under-growth. This is his depiction of the story of Pyramus and Thisbe. We are accustomed to regard this as broad comedy because of the 'play' put on by Bottom and friends in Shakespeare's *A Midsummer Night's Dream*, but it is a genuine tragedy.

Pyramus and Thisbe were lovers whose families lived side by side but hated one another. The lovers could never meet but only speak through a hole in the party-wall, until they finally decided to steal out one night and come together at a tomb where they would not be seen. Thisbe arrived first and discovered a hungry lioness, rending its prey. She ran away, but the lioness, as cats do, played with the scarf she dropped and bloodied it. When Pyramus turned up he found the scarf and traces of the lioness and jumped to the conclusion that Thisbe had been killed. He felt great grief and even greater guilt. It was his late arrival, he thought, that had led to the tragedy, and in a passion of sorrow and self-disgust he killed himself. All too late, Thisbe returned, and she too felt herself to blame: it was because of her that he had lost his life. So she took his sword and joined him in death.

The legend says that there was a white mulberry tree at the meeting-place, whose fruit turned scarlet because of their blood, a myth wittily suggested here by the scarlet cloak that spreads out under Pyramus like a great pool, and by Thisbe's white overskirt that will redden like her underskirt when she stabs herself. There are Baldungesque touches every-where, from the ominous sky with its hidden moon to the sad little cupid on the pillar and the two fountains with their separate pools.

Remarkably, Baldung makes the lovers far older than the adolescents of the original tale. This is serious heartbreak between mature people. But the most characteristic element, springing from his fear of the feminine, is the position of the two figures. We know that both die, but what we actually see is the man, recumbent in death, and over him, tall, erect, fateful, looms the woman.

Pyramus and Thisbe **Hans Baldung** c.1530
Oil on panel 93 × 67cm (36⅝ × 26⅜in)
Gemälde Gallery, Dahlem Museum, Berlin, Germany

St Ulrich and St Barbara

HANS BURGKMAIR

Born Augsburg, Germany 1473
Died Augsburg, Germany 1531

These two magnificent panels by the little-known artist Hans Burgkmair used to stand in a church. I must admit I am glad they are now in a museum because they make me laugh. This is not because of their respective stories, I hasten to add. The saint on the left is Ulrich, as we know from his emblem of a fish. The legend, which I agree is mildly humorous, is that he once gave a messenger a gift of meat, completely forgetting that it was a day when meat was forbidden by church law. The messenger, who must have been a rather nasty character, immediately went off to denounce Bishop Ulrich. When he self-righteously brought forth the evidence of the meat, it had mysteriously changed into a fish!

St Barbara's story is wholly serious. Her emblems are double. One is a tower, because she was imprisoned in one by her father who did not want her to become a Christian. She did become one and as a result he had her beheaded. As her head was struck off there was a tremendous flash of lightning, which killed her cruel father and has made her the patron saint of artillery. Her other emblem is the chalice and host, the last sacraments, since she died so heroically.

The stories merely tell us that Ulrich was a kindly if absent-minded bishop, while Barbara was a very courageous martyr. But look at what Burgkmair has done with them. Ulrich is clearly a saint: he wears his episcopal robes, he has a noble countenance, his eyes are sunken with prayer and penitence, and he looks beseechingly up to heaven. He is a believable saint. Compare Burgkmair's treatment of the female saint, Barbara. She is bedizened to the skies, her bosom swells with large pearls, her very petticoat is embroidered. She stands commandingly, a hussy of the first water. Her face is prim with upper-class hauteur, and hard, like a courtesan's. It is impossible to believe that this woman is a saint.

Holy Ulrich and Barbara the floozie: why? Why should the man be clearly a saint and the woman so clearly not? Can it be that Burgkmair is a sexist? Faced with this horrible possibility, I refuse to be irritated and opt for benign amusement.

St Ulrich
Hans Burgkmair C. 1518
Oil on panel 105 × 41cm (41⅜ × 16¼in)
Gemälde Gallery, Dahlem Museum, Berlin, Germany

St Barbara
Hans Burgkmair C. 1518
Oil on panel 105 × 41cm (41⅜ × 16¼in)
Gemälde Gallery, Dahlem Museum, Berlin, Germany

Altdorfer's *Allegory* is an enchanting little picture. The more I see it, the more I love it, but it is a strange work. It is dominated by an extraordinary castle, each corner of which is different, bizarre in its complexity and seeming to sprout balconies and colonnades on every side. It is all the more surprising because Altdorfer was also an architect. It is weirdly unpeopled, a huge building empty except for the two aristocrats in the courtyard. One holds aloft the golden goblet of welcome, while the other slouches against the balustrade, watching with bemusement the absurdly overdressed couple sweeping up towards him. On their train travels, in comfort and happiness, a little family of the poor. All is set in a wonderful, fairy-tale world of light, peace and sunshine. But what does it all mean?

It is obviously an allegory that is concerned with riches and poverty. At first I tried to give a kindly interpretation and see it as meaning that the rich always take responsibility for the poor, but I think Altdorfer is too much of a realist to be saying that. Perhaps the meaning is rather that we cannot escape our backgrounds. This is the Gemälde Gallery's interpretation: the beggars are sitting on the train of the *nouveau riche*, the upstarts, the pompous. If we begin in a slum we carry the slum with us, for ever connected to the family back in the tenements and to our memories. This is the usual meaning, and an acceptable one.

To me, though, it does not quite account for the magical, unreal, dreamlike quality of the picture. Take the castle; in the landscape there is a perfectly normal castle, so why is this one so fantastic? My suggestion, which I shall not take up arms to defend, is that we are looking at the dream-world of the *nouveau riche.* They can imagine their grand, expensive, elaborate castle, and a welcoming nobleman – and then their imagination falters. They do not know how this upper-class existence works. The one thing they do know is the type of existence they have come from, and that is represented by the beggar family. They do not try to shake them off: they accept them, because they are tied by blood. It is this heartening touch of down-to-earth realism that makes the dream so charming.

Allegory **Albrecht Altdorfer** 1531
Oil on panel 28.5 × 41cm ($11\frac{1}{4}$ × $16\frac{1}{8}$in)
Gemälde Gallery, Dahlem Museum, Berlin, Germany

Hôtel Carnavalet

Notre-Dame

Louvre

Arc de Triomphe

Opéra

PARIS

Everybody told me that Paris was a city of ravishing beauty and that I would love it. If I confess to being disappointed, it must be because my expectations were impossibly high. I had a dream of a romantically sun-dappled city, all greenery and medieval architecture; the reality of the noisy traffic and the preponderance of massive nineteenth-century buildings weighed down my spirits. There were, of course, delights to be found, and in the end I forgot both the disillusioning and the exhilarating in the presence of the actual art in the galleries.

The Musée d'Orsay may be a rather weirdly shaped museum, fashioned as it is out of the great former railway station, but it provides space and light in which to contemplate roomfuls of Cézanne and Manet, Courbet and Corot, Degas and Gauguin. Cézanne is the painter I prize above all others, and there was a sort of sweet agony in having to decide on just one masterwork: the marvellously luminous landscapes, the noble still lifes, the portraits? There is a whole row of *Bathers*, the theme that engrossed Cézanne all his life and that I have come to love best of all his works. I played with the idea of *The Card-players* or the *House of the Hanged Man*, but the serious choice had to be among the variously dated *Bathers*: all superb.

Then there was the Louvre, not a pleasant museum physically, but I had the privilege of seeing it on its closed day, when no one else was around. There is something eerie about being alone with the *Mona Lisa*, able to 'see' her without company, yet somehow never able to 'see', because she has become too familiar to us as icon. Small and darkened as the picture is, it lives a subliminal life of its own in the modern consciousness: the supreme image of enigmatic beauty. I tried to pierce through the veils of accreted myth, seeking an encounter with the young Italian wife who sat to the famous Leonardo for her portrait. She evaded me, yet I cannot free myself from that failure. It is as if *Mona Lisa* affected me more by this evasion than if I had succeeded, and this may be the secret of the work's greatness. She stayed with me as I went on to meet the other masterworks in the Louvre, and was invisibly present in her very absence! Ironically, I had thought I would escape her challenge because I intended to speak only about French artists in this great French museum, but then recalled that Leonardo ended his days at the French court and is an honorary Frenchman.

I have always loved Cézanne, always found him completely satisfying. I think this is because he is doing two infinitely important things. He is utterly committed to what he called his 'sensation', to a total visual experience of the real world, and he is equally committed to expressing that in paint. It is an impossible ambition, because the real comes at us from all directions at once, changing as the light changes and our position moves, yet Cézanne was reluctant to leave out any one of these directions. He longed to make totality visible, while suffering the agonizing sense of inevitable failure; it is this radiant anxiety that gives his work its force.

Since what he painted was based on visual response, he always painted with the subject in front of him, whether it was a mountain or a still life; with one exception: his compositions of bathers. It is not until now, when I am relatively old, that I have come to understand their greatness. Cézanne was a prudish man, afraid of the flesh; nothing would have induced him to ask models to unrobe at the river. But he was also an intensely truthful man, aware that the flesh matters supremely, and that he had to come to terms with it.

This particular version is of male bathers; he not only used his customary photographs and his prints of Old Master paintings of bathers, he also drew upon his own memories. The one time when he seems to have been truly happy was when he was a boy in the countryside, bathing with his friends, and there is a great force of nostalgia behind this picture, one of the times when this theme, to which he returned obsessively all his life, is triumphantly successful. Although he is using memories, they are memories of what is irrevocably past, and he expresses that by blocking us out of the picture. The two men in the middle shut us out, with the dangling towel reinforcing the exclusion. We cannot get into the scene, any more than Cézanne can return to his carefree youth.

He has buried the figures in nature, with the clouds following their contours and a lozenge-shaped woodland enveloping them. In case that seems too imprisoning, great trees shoot out of the centre like rockets, not real trees any more than these are real bathers, but the essence of tree, just as the young men are essential flesh. This anxious, beautiful joy is something that we actually need.

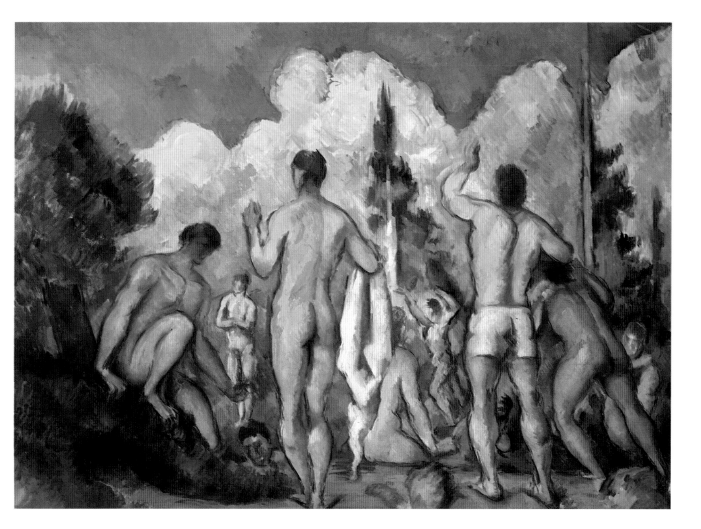

The Bathers **Paul Cézanne** c. 1890–2
Oil on canvas 60 × 82cm (23$\frac{5}{8}$ × 32$\frac{1}{4}$in)
Musée d'Orsay, Paris, France

The Balcony

ÉDOUARD MANET

Born Paris, France 1832
Died Paris, France 1883

The nineteenth-century art world was thrown into a ferment of rage and confusion by Manet. Looking at the sheer beauty of a work like *The Balcony*, we may wonder why, yet they were right to be disconcerted. Manet is, even today, a profoundly disconcerting artist, always suggesting the presence of some unacknowledged mystery.

The three people on the elegant balcony were all friends of his. (A fourth friend, posing as a serving boy in the background, was a relative of his wife. He is only there to make credible the idea of an inner room, a potentially private space, which these three are choosing to forgo.) At the rear stands the man, bored and vacant, tilting his head like a lordly pasha. The women, diaphanous in white, look idly in different directions, one playing with her gloves, the other glooming sullenly into the distance.

Yet these vacant and silent people are actually electric with potential. The man is Antoine Guillemet, a landscape painter (whose work hangs round the corner from the Manet room in the museum); the standing woman is Fanny Claus, a noted violinist, holding her parasol as if it were her musical instrument; the seated woman is his fellow Impressionist, Berthe Morisot. Yet, however great their gifts – and in Morisot's case, her beauty as well – they are trapped by the balcony, by 'society', into an ineffectual dullness. They do not communicate; even the dog looks away from his ball and shares no common focus with the three humans.

Strong verticals of green hem them in from either side and rise up aggressively in front. They are there in full view, there to be seen, and it is this artful idleness that seems to motivate the painting. The only vibrant colour is the startling blue of the male cravat; we are assailed with a wild sense of energies unutilized, communications stunted, life unlived. The sultry splendour of Morisot, whom Manet's brother would later marry, underlines the sheer futility of society and its cages, which are nevertheless freely entered into by all here before us, except perhaps the dog.

Cool and summery, aloofly and beautifully intelligent, *The Balcony* offers the most subtle of challenges to values too easily left unanalysed. Manet is a silken revolutionary.

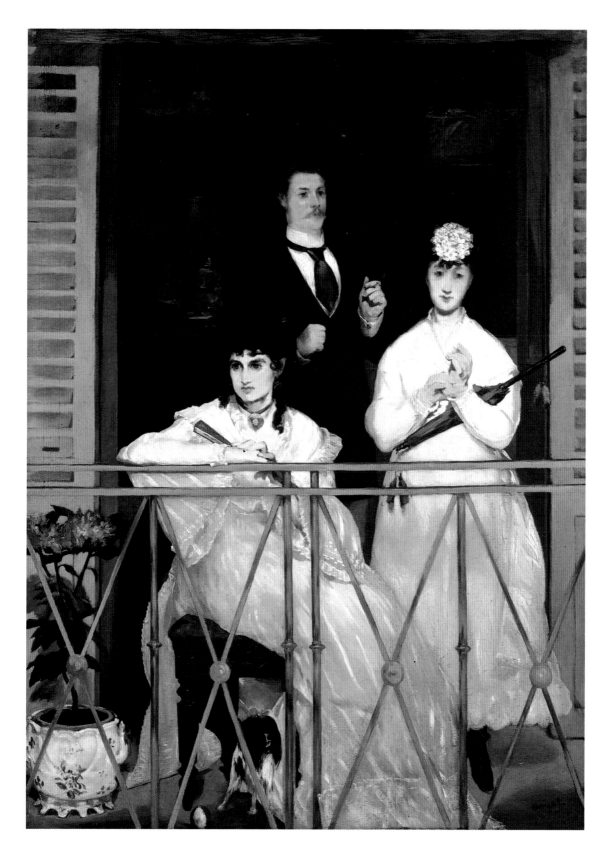

The Balcony **Édouard Manet** 1868–9
Oil on canvas 170 × 124.5cm (66$\frac{7}{8}$ × 49in)
Musée d'Orsay, Paris, France

Gilles

ANTOINE WATTEAU

Born Valenciennes, France 1684
Died Nogent-sur-Marne, near Paris, France 1721

Watteau usually painted rather small pictures with a sort of melancholy charm. I love them, but they do not make my heart stop with wonder. *Gilles*, however, really is a heart-stopping picture. It is a depiction of Gilles, or Pierrot, probably painted for a friend who habitually played this part in the *commedia dell'arte*. This is an art form that has now died out, though I am told our modern equivalent is the television comedy. There were always the same characters, such as Harlequin, the crafty villain who won the girl, and Pierrot, the stupid, well-meaning clown who never quite got there.

The actual scene Watteau shows us is rather mysterious, certainly not a scene from any play. The four actors at the back, or five if we count the donkey (the most intelligent of the lot by the look of him!), are clearly involved in some action. The man on the donkey is the Doctor and the brightly coloured man is the Captain, and they are all communicating. But Pierrot is alienated from them, perched aloft and exposed.

An actor protects his privacy through words and actions; Pierrot has been deprived of them. He simply stands there, limply, to be looked at. He is a figure of fun as far as his costume goes: those foolishly short trousers and the impractical sleeves that are too long, his collar like a horse's halter and his feet pathetic with their pink ribbons. Yet, though wearing this funny costume, Pierrot stands there without a funny face. He confronts us with his own face, a real and intelligent, personal face: young, honourable, composed and brave. He stands like a St Sebastian to be shot at, or like a slave to be auctioned, not evading us but looking intently and yet enigmatically out at his viewers.

It is this contrast between what he is dressed to seem and what his face reveals that he is, that makes the picture so arresting. It is painful to be looked at unless we can be certain that it is our true selves that are seen. To be truly seen as what we are: that is a deep joy. But so often we feel that life does not allow us to show our truth, that our role or context disguises us: this is where the pain and the courage of Gilles become so relevant. He is an actor – a figure of fun – in his outer garb; a real young man – a serious person – in himself. He stands on high to be looked at, to brave our stare: what do we see? To me Gilles is noble even heroic, an image of how we would all desire to confront life and its mockeries.

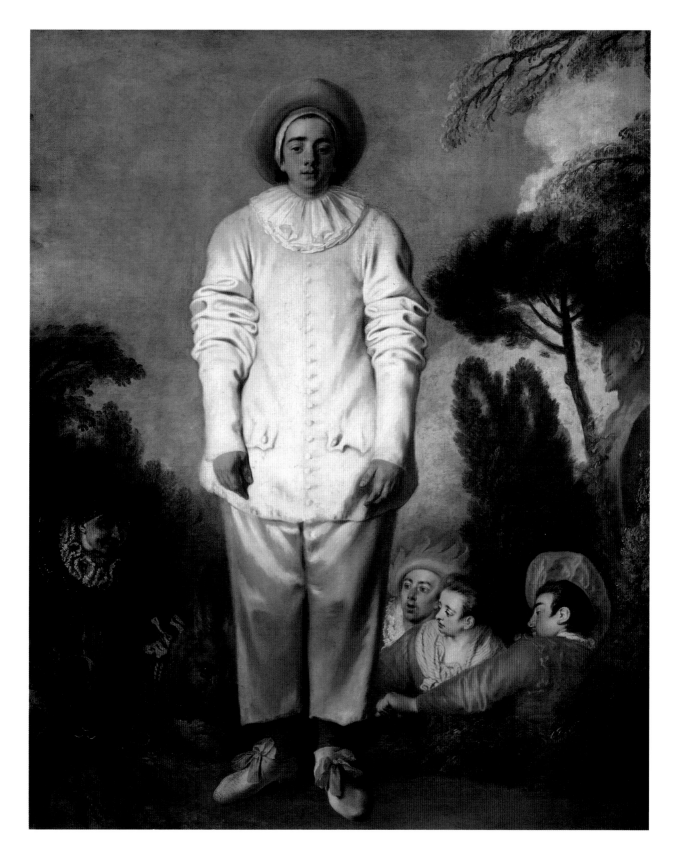

Gilles **Antoine Watteau** c.1718
Oil on canvas 184.5 × 149.5cm (72⅝ × 58⅞in)
Louvre Museum, Paris, France

Inspiration of the Poet

NICOLAS POUSSIN

Born Les Andelys, Normandy, France 1594
Died Rome, Italy 1665

Anyone with a passion for Poussin finds a happy hunting-ground at the Louvre. One of his great early triumphs was the *Inspiration of the Poet*, though 'triumph' is too crude a word for the gracious elegance of this painting. Poussin presents us with a classical frieze showing the muse of epic poetry, Calliope, the god of poetry, Apollo, and the poor, young, earthly poet with his tousled hair and look of anxiety. He is earnestly seeking for 'inspiration' so as to 'succeed', and the symbol of success is the laurel wreath.

The painting suggests that the poet sees two directions in which to look for that success. One is downwards, where a cherub holds a laurel wreath in one hand and a book in the other. This is one way to search, because you only create poetry out of the depths of your own being, and the more enriched that being, the greater the poetry. So we need books, learning, knowledge: Apollo's foot rests upon books. But this is not the only way, as we also need to reflect within ourselves and to look out, to search infinity; hence the other direction is upwards. There too a cherub waits to crown the poet.

Notice, though, that the poet has not yet actually written a single line. He is holding his pen and waiting for inspiration, and Apollo regards him with a godlike impatience. Whether looking up or down, the youth is searching for reward, eager to 'become a poet'. Apollo sits like a priest between the youth and the muse and the hint is clear: he should look in a completely different direction – across. There is waiting his own personal muse, one lovely breast already bared, holding her flute. She carries no laurel wreath but is herself wreathed in laurel. The poet has to forget all about himself and the desire to be poetic and simply accept the reality of love, of becoming a full human being. He needs this completion, and in that profound relationship he will find his poetry.

Shakespeare asked in *The Merchant of Venice*:

> Tell me where is fancy bred,
> Or in the heart, or in the head?
> How begot, how nourished?

Fancy or imagination or inspiration is not a partial thing, replies Poussin. It is neither heart nor head but the entire person, forgetting about self and glory and intent upon the Other. It is fulfilment that makes the poet, as it makes the artist, and just to look at a picture like this one is to share in fulfilment.

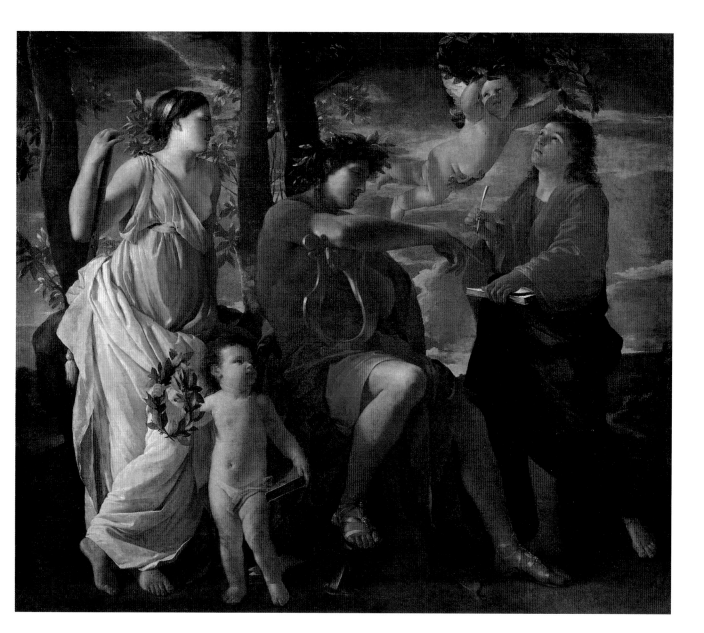

Inspiration of the Poet **Nicolas Poussin** c. 1 6 3 1 – 2
Oil on canvas 182 × 213cm (71$\frac{5}{8}$ × 83$\frac{7}{8}$in)
Louvre Museum, Paris, France

Ingres had a very high idea of the spiritual vocation of the artist, but he is really only completely at ease when dealing with the simplicities of the flesh. He gives us a splendid illustration of the story of Oedipus and the enigma of the Sphinx, trying to make us see it as the riddle of the eternal feminine. (Notice the bodies down below of the men destroyed by Woman's wiles and how the Sphinx thrusts her breasts at this nobly nude hero.) The actual enigma was a rather simple one: what had four legs in the morning, two at noon and three at night? Clever Oedipus realized it was the human being, who crawls when young, then stands, and has a stick in old age. But bodies as such do not really challenge Ingres, and so do not force him past competence.

What makes him rise to his true potential is any need to depict not the body but the spirit, the reality of another person confronting him. A very young Ingres, faced with a still younger Mademoiselle Rivière, is able to cope only by a fierce distancing. He has to objectify her, turn her into an impersonal and porcelain beauty. He produces an uncanny icon, the supreme example of a person who is wholly real but about whom we can deduce nothing. There she stands with her swan-like neck, her perfect head, her broad, clear brow. What thoughts lie behind it? Ingres does not tell us, not only because he does not know but more because he does not want to know, is determined not to know.

He paints her with infinite finesse, but with an amazingly material touch. See how the feather boa wraps round her without a hint of the erotic: it clings more like a boa constrictor. It is only the outside he dares look at, those gorgeous clothes so minutely pleated: pleated gloves, pleated dress, as if he pleats the person as finely as he can so as to be more able to deal with her. Even the background is like a stage set, distancing her. There is a weird imbalance in her body, the gloves too large, the head too small, as though he were pressed too close to her to be able to get his proportions right.

Most paintings of the young have a strain of vulnerability, which would have been peculiarly apt here as this child died soon after the portrait was painted. But the truly vulnerable one is Ingres himself, propelled into magnificence by his human fear of personal encounter.

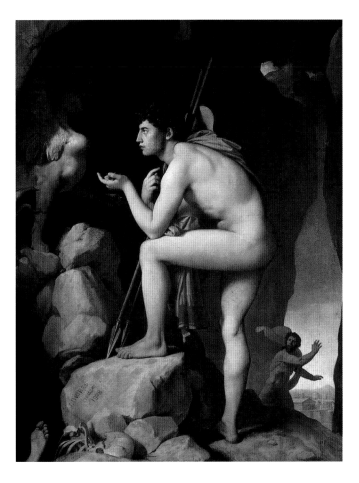

Oedipus and the Sphinx
Jean-Auguste-Dominique Ingres 1808
Oil on canvas 189 × 144cm (74$\frac{3}{8}$ × 56$\frac{3}{4}$in)
Louvre Museum, Paris, France

Mademoiselle Rivière
Jean-Auguste-Dominique Ingres 1805
Oil on canvas 100 × 70cm (39$\frac{3}{8}$ × 27$\frac{1}{2}$in)
Louvre Museum, Paris, France

Matisse was an intensely private man. Picasso made art out of his own private dramas, but Matisse did not, and the unusual thing about this picture is that it is a self-portrait of Matisse in his pyjamas and Madame Matisse in her dressing-gown, confronting each other. It is an image of marital alienation, and I suspect he did not realize how revealing it was. We are probably meant to universalize it, to read it as any two partners in a marriage that is not working.

It is the husband who is seen as the dominant figure. The wife is low down, low on the totem pole, as it were. She is imprisoned in her chair, its great arms shutting her in, and the bag-like dressing-gown enwrapping her feet. She has no feet, apparently: she just ends, as if she were passive, not needing feet, since her husband is the sole source of power. Her eyes are blots of darkness, and though she tilts her head tensely and aggressively, we feel it is useless. The husband is a great long streak of power, shooting up and out of the picture, as if he continued on into infinity, whereas the wife is wholly contained. He is free of the picture-frame, a freedom emphasized by the arrow-straight body and the strong white lines of his pyjama suit. All about

him suggests contained power, from his great thick neck to his affinity with the natural world outside. The male body rhymes with the tall upright trees, whereas the female is only in tune with the rounded ponds, none of which is allowed to complete itself: they are all intersected.

Her introverted pose is also taken up by the curlicues of the railings, and it is here that Matisse adds a witty and elegant note of interpretation. The curves of the railings spell out: *NON*. Matisse and his wife are saying 'No' to each other, but saying it silently. The 'conversation' is one of the heart, since both have their mouths firmly shut. There is no need for actual speech; their very body language shouts out this rejection, this *Non*, and so does the marked distance between them. They are apart, not because they are physically so but because they are mentally so. Yet, despite this separation and mutual rejection, the deep expanse of radiant blue in the picture, the lovely patterning of form and colour, somehow takes the edge off the argument. In the end it is not a sad picture, but a strong, funny and serious picture, since everything works in it, everything sings, even if the lyric is a loud but musical negation.

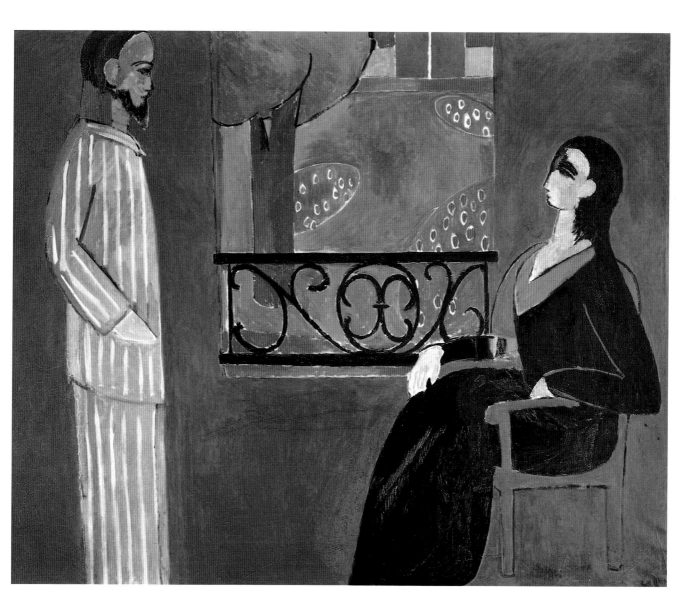

The Conversation **Henri Matisse** 1909
Oil on canvas 177 × 217cm (69⅝ × 85⅜in)
Hermitage Museum, St Petersburg, Russia
(temporarily exhibited at the Pompidou Centre, Paris, France)

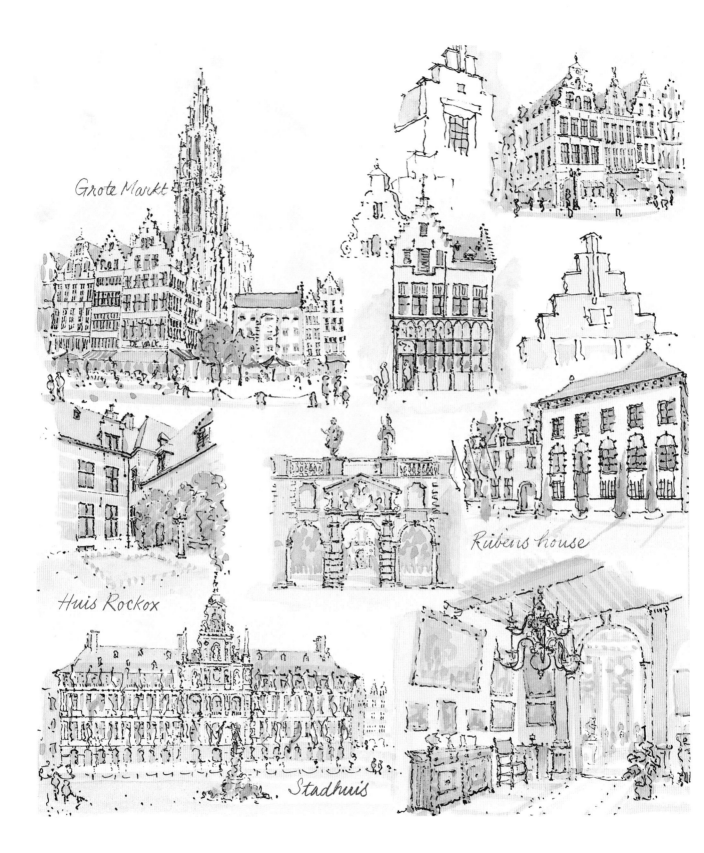

Grote Markt

Rubens house

Huis Rockox

Stadhuis

ANTWERP

There is a gentle elegance about Antwerp that is surprisingly evocative of Flemish art. I say 'surprisingly', because we often think only of the more robust artists from the region that is now Belgium: the muscular Jordaens or the lovely plumpness of the Rubens' women. Yet Rubens is also one of the supremely poetic painters, and even Jordaens has a wistful touch. But think of van Eyck, van der Weyden, Joachim Patinir, Quintin Metsys or Petrus Christus, and the images that come to mind are almost ethereal in their beauty.

Antwerp has two of these unworldly van Eycks: *St Barbara* and the *Virgin of the Fountain*; they are small and exquisite and I love them intensely. They shine sublimely out from the walls of the Koninklijk Museum, as does one of the greatest of Patinir's works, the *Flight into Egypt*. Apart from the magical bird's-eye view of the landscape – this from an artist who could not have seen it from so high, in those days without aeroplanes – Patinir has told the whole legend of the hurried journey that Mary and Joseph took into Egypt, refugees with the Christ Child from the wrath of the jealous Herod. Its tiny delicacy is for personal contemplation.

This same museum has a wonderful *Mary Magdalene* by Metsys, a saint who is usually depicted with a certain amount of drama: grieving over her years as a prostitute or at least more obviously as a glamorous woman. Metsys' Magdalene has a face worn with living, quiet and thoughtful. She is dressed with Flemish modesty and lingers in my mind as one of the most touchingly dignified portraits I have ever seen.

Antwerp is rich in museums. Rubens' house, the mansion he raised by his artistic efforts, recalls his effortless grandeur on every floor and in the gracious garden. He, Jordaens and van Dyck, the three greatest painters of Renaissance Antwerp, are glorious in churches and museums throughout the city, the great Baroque sweep of their line complemented by the still inwardness of the earlier artists. I loved everything I saw.

Atalanta and Meleager

JACOB JORDAENS

Born Antwerp, Belgium 1593
Died Antwerp, Belgium 1678

I had never taken much interest in Jordaens, who seemed to be Rubens without the poetry. If Rubens is a symphony orchestra, then Jordaens is a brass band. But looking at a work like this has made me realize that I actually like brass bands.

My first reaction was a smile of astonishment, because Atalanta is the famous fleet-foot girl, and she is usually shown racing against her suitors. But this is an earlier story. Meleager, the angry young prince shoulder-to-shoulder with her, had summoned the heroes of Greece to help him destroy the huge boar that was ravaging his father's kingdom. Among the heroes was Atalanta, a great sportswoman, and she was probably welcomed with amused condescension. But once the hunt got under way, the only hunter to wound the boar was Atalanta. Although she did not kill it, her arrow-shot made it possible for Meleager to cut off the savage head. He was enormously impressed: love at first shot. He showed his love by insisting that the trophy of the head should go to Atalanta, to the fury and chagrin of the others, especially his uncles.

Here we see the threatening uncles looming ominously in the background while the two young people are ringed in by implicit menace: dogs thrusting up, hands thrusting up, the boar's teeth thrusting up. It is a moment of drama, and Meleager, a hot-tempered youth, is already reaching for the sword with which he will attack and kill his jealous uncles, and so bring about his own death at the hands of his mother. For Atalanta, this is a moment of glorious realization: she is not only loved, she is matched. She and Meleager are alike: great muscular creatures with bright eyes and high courage. If she seems rather large for a notable sprinter, she would at least do well in the discus, and she is far from unfeminine, with a flower in her hair and earrings.

Jordaens convinces us by his truthfulness to what he knew: the hefty, wholesome Flemings of his era, and he convinces us that these people are engaged in a serious confrontation. It will mean death for Meleager, and for Atalanta the loss of her trust in love. It will take her years to recover. This is their last shared moment of love.

Atalanta and Meleager **Jacob Jordaens** c.1617–18
Oil on canvas 152 × 120cm (59⅞ × 47¼in)
Koninklijk Museum, Antwerp, Belgium

Venus Frigida

SIR PETER PAUL RUBENS

Born Siegen, Germany 1577
Died Antwerp, Belgium 1640

Venus Frigida hangs on the end wall in a large gallery, and one can stand at the opposite end and see it gleaming out on the whole room, shining forth the message so typical of Rubens, that love is the brightness of life. Perhaps only he could take a rather commonplace proverb and make it magical. The proverb is that Venus freezes without the presence of Bacchus, or, in everyday language, without food and drink, you do not have the energy to love. The great beautiful body of the goddess of love is shivering, wrapped in on itself, aware only of the cold. Poor silly Venus is too miserable even to realize that she is, in fact, sitting on her cloak and could do something to quell the goosebumps. But she is too frozen even to function intellectually, let alone emotionally, and that is Rubens' point.

This could have been a rather cynical picture, but instead it is both truthful and profound. Love, Rubens is saying, is a matter of relationships. Love goes out to another, which is exactly what Venus is not doing. She is solely occupied with herself, her long white legs curved in, her hands knotted in, her face averted. Instead of longing for somebody else, she is not even conscious of them, neither of sad little shivering Cupid nor of Bacchus looming out of the darkness with coming succour. Rubens does not blame her. He is explaining that this is our condition: body and soul are too intimately united to function separately. Love is the central light, but that spiritual brightness needs material sufficiency to glow in its fullness, person to person.

One of the reasons why I so love Rubens is his reverence for our wholeness, his humble cherishing of the body. He never abuses it or holds it cheap. He never gives it a meretricious over-importance. He takes being human with complete seriousness, but also with humour, delight and lyric strength. A wise and balanced man, Rubens understands that love does not function in a vacuum but needs – actively and essentially – material support.

Venus Frigida **Sir Peter Paul Rubens** 1614
Oil on canvas 142 × 184cm (55⅞ × 72½in)
Koninklijk Museum, Antwerp, Belgium

The Lance

SIR PETER PAUL RUBENS

Born Siegen, Germany 1577
Died Antwerp, Belgium 1640

A painting like this comes very close to the bone for me, because it shows the death of someone I love. It takes us beyond what some people would consider as the 'narrowness of religion' by making it so clear that a religion only works when it is based upon the deepest experiences of the human heart. If I were trying to explain this picture to those who had never heard of Christianity, I would tell them to regard it as a great meditation upon the meaning of death. It is centred on a depiction of three ways of dying.

On the right we have one of the two thieves who were crucified with Christ, the so-called 'bad thief'. He has been called this because he died badly. He died raging against death, closed up in himself and his own bitterness and frustrations, hostile to everyone and aware only of himself. He went screaming into eternity; please God none of us die like that.

On the left is the 'good thief', good because he died trying to do a kindness to another. Dorothy Sayers suggested that he regarded Christ as a sweet and loving lunatic, a man who had the delusion that he was divine and was now suffering total failure. The good thief spent his last breath saying, out of compassionate concern, 'Lord, remember me when you come into your kingdom.' The dying Jesus raised his head and replied, 'This day you will be with me in paradise,' and the good thief slipped happily and sweetly out of life. This is the death we all desire, a death of unselfishness and of peace.

In *The Lance*, Jesus is already dead; his last words, said just before his side was pierced by the lance to prove that he was now bloodless, are hard to translate: *Consummatum est* in Latin, something like 'It is done, absolutely everything has been given' in English. To have achieved the utter fulfilment of all potential, to have become completely human: would that we could die like that. Around the three who are dead or dying are three other groups of three. The executioners, astonished and active; the mourners, passive in the intensity of grief; and the interconnecting group of Magdalene and the bystanders: us. Rubens integrates the whole world with magnificently unselfconscious emotion.

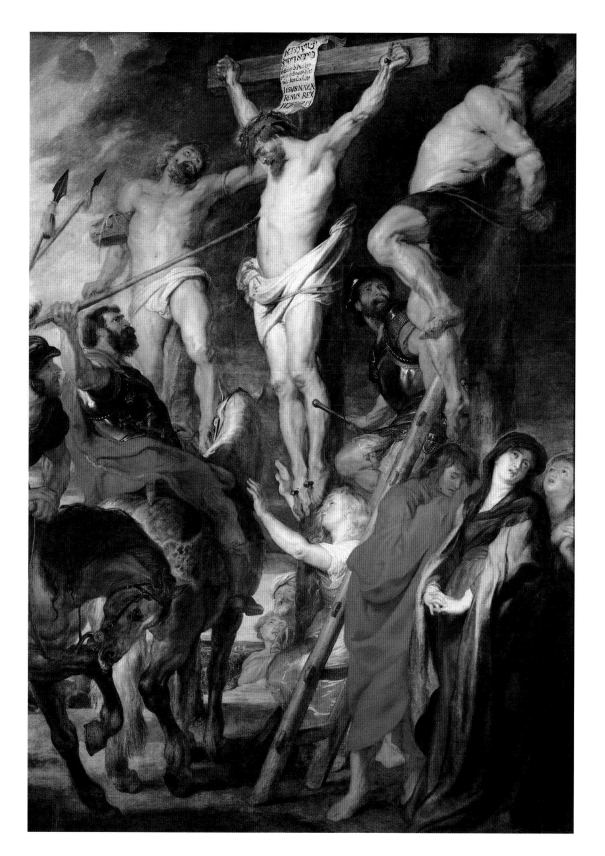

The Lance **Sir Peter Paul Rubens** c.1618–20
Oil on panel 429 × 311cm (168$\frac{7}{8}$ × 122$\frac{1}{2}$in)
Koninklijk Museum, Antwerp, Belgium

Dulle Griet

PIETER BRUEGEL THE ELDER

Born near Bree(?), Belgium c.1525–30
Died Brussels, Belgium 1569

This is a rare instance of a picture that I do not actually 'like', but which has such presence, such a sinister vitality, that I cannot forget it. It is so full of incident that it almost frightens me with its complexity, yet Bruegel is one of the most lucid of artists (razor-sharp of mind, tender of heart).

The key to understanding the painting is the strange head on the left, the giant mouth of hell. What we are seeing is a charming little medieval city, rather like Antwerp itself, and it has become a colony of hell. The air has thickened, smoky with flames and evil spirits. There are misshapen creatures all around, and there is a special note of horror in that nobody even seems to notice or fear them; they are an accepted part of the landscape. On all sides people are attacking each other with a horrible sense of ferocity, of things going wrong, and at the centre of this human wrongness strides Dulle Griet.

Griet is short for Margaret, and she has been anglicized as 'Mad Meg', although *dulle* is more than simply 'mad'; there is an hysterical violence in its meaning. Despite her size, she is strangely diffident, with a defensive quality that mingles bravery and timidity. Her gaunt, painfully intent face arouses our compassion, with male armour slung around her so unskilfully and her loot such a weird mixture of the precious and the commonplace: silver caskets and frying-pans.

Pages have been written as to what Dulle Griet represents, and my theory, which is only mine, is that her meaning depends upon the significance in the painting of the other giant figure, the man. He is sitting not inside the house but outside it, on the roof, marginalized. With one hand he bears the heavy but nonsensical burden of the ship and its strange crew, and with the other he holds a ladle. His rear part has been cracked open like an egg, and he is excreting coins and painfully helping them to fall. What do we have? A man producing money with labour, bearing the burdens, not included in the family, while the woman roams free and loots. Their relationship has gone wrong, there is imbalance, there is no love or sharing. Without that, says Bruegel, life is hell.

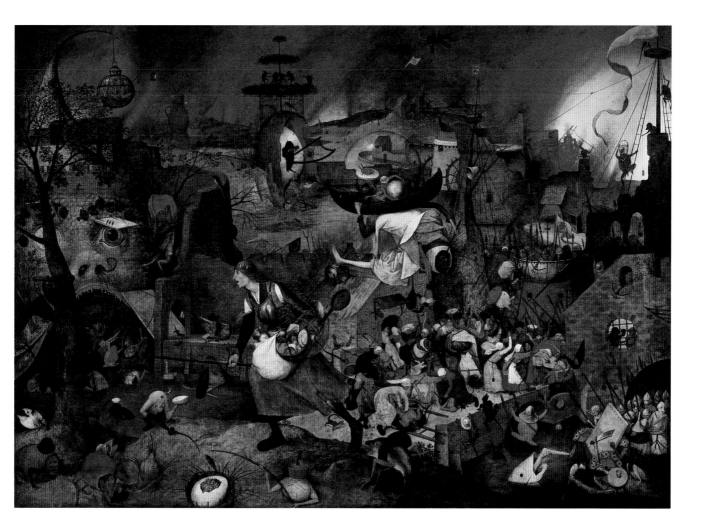

Dulle Griet **Pieter Bruegel the Elder** 1562
Oil on panel 117.5 × 162cm ($46\frac{1}{4} \times 63\frac{3}{4}$in)
Mayer van den Bergh Museum, Antwerp, Belgium

St John Resting on the Bosom of Christ

MASTER HEINRICH OF CONSTANCE

Dates unknown

Flemish art is very rich (including, in the Mayer van den Bergh Museum, a superb work by Pieter Bruegel the Younger, a creative copy of his father's *Triumph of Death*) so I feel almost ashamed to confess that here I have cheated. I wanted to explore only the wonders of its national art in Antwerp, and this carving is by a Swiss, whose very surname is unknown. But I cannot pass this by: it is one of the most beautiful things I have ever seen.

Here is Jesus, a young man in his twenties, and his friend John, a young man in his late teens. John is leaning on Jesus with total trust. It is the perfect expression of friendship when one partner is a little older. John knows for certain that Jesus will protect him, care for him, always put him first, never act other than as a big brother. The very way the work has been carved emphasizes this. There is no space between the two, no gap; these are two who think alike. John does not hold the hand of Jesus but merely rests his hand on it. The older friend provides a firm platform, absolute support. There is a wonderful sense of peace and a kind of rhythmic serenity in the curving flow of the drapery, telling us that there is no passion here, no great emotionality, just love.

But if we want to experience the full impact of this sculpture, I think we have to imagine it back into its original setting. It came from a convent. For centuries it stood in a contemplative convent, a monastery, as an example to the sisters of the meaning of prayer. It is impossible to be a nun without understanding prayer (a living understanding, not an intellectual one). If one is going to spend hours praying everyday, these cannot be hours of talking, or asking, but hours of loving. Prayer is essentially resting one's head on the heart of God, certain that He knows. Prayer is complete surrender. A nun takes a great gamble, that without the normal fulfilment of a partner and perhaps children, she will still become a complete woman. She has unshakeable faith that resting on God will mean human fulfilment, which is what this sculpture shows. So it is special for everybody, but it is particularly special for me.

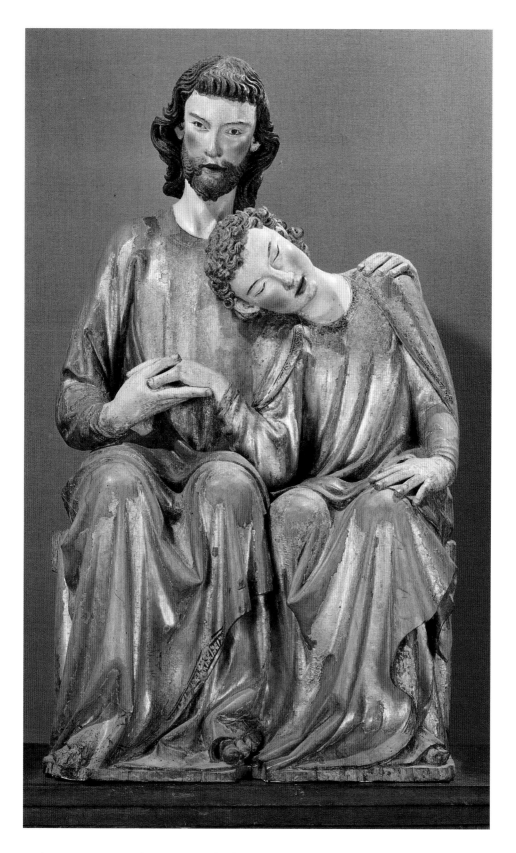

St John Resting on the Bosom of Christ **Master Heinrich of Constance**
early 14th century
Wood ht 141cm (55½in)
Mayer van den Bergh Museum, Antwerp, Belgium

Canal houses, Amsterdam

AMSTERDAM & THE HAGUE

The Netherlands is one of those miraculous countries, like Belgium: so small, so geographically unromantic, so astonishingly rich artistically. The friendliness of Amsterdam, low-key, just a touch zany, offered no hint of the profundities waiting to be looked at in museums such as the Rijks or the Van Gogh. I spent my time there in an almost constant state of wonder. The Rijksmuseum had just finished a massive work of restoration of some of their great Rembrandts, and that alone was sufficient cause for awe. A sensitive cleaning has revealed works like *Titus as a Monk* or the *Denial of St Peter* as even more beautiful, more luminous with an inner intensity than I had realized.

Skimming along to the Rembrandts I was arrested by the face of the *Woman Warming her Hands at a Brazier*, a painting by a relatively unknown artist, Caesar van Everdingen. It is a plain face, wholly serious as it concentrates on the brazier, which is concealed beneath a cloth. There is a sense of the sacramental, of something at stake. The young woman is dressed not only in costly seventeenth-century bed attire, she is also wearing her earrings and pearls, dressed in her finery for an empty bed; yet she is not repining but making do with her loneliness and setting herself to cope. Finding a minor artist so transcending himself, which suggests that the theme had some personal significance for him, is one of the unexpected delights of a Grand Tour.

The expected delights were even greater. Amsterdam has a wealth of quietly majestic Vermeers, so that it seemed almost greedy to travel the short distance to The Hague where there hangs the greatest of all Vermeers (perhaps of all Dutch pictures?), the *View of Delft*. The Mauritshuis at The Hague, which is the Queen of the Netherlands' own collection, also contains some wonderful Rembrandts, like his moving *Susanna*, crouching with such vulnerable grace as she realizes her bath is being spied upon, and a haunting pair of early and late self-portraits. Perhaps the Dutch have a special gift for self-portraits, with van Gogh staring out at us with bleak intentness in the Van Gogh Museum and ter Borch looking reassuringly normal at the Mauritshuis. The Netherlands reminded me of Christopher Marlowe's great line: 'Infinite riches in a little room'.

This is one of the famous pictures of van Gogh's bedroom. All his work is intensely personal, which is one of the reasons why we love it, but nothing is so personal as one's private bedroom. This was the first time that van Gogh, perpetually unsettled, had had a house of his own, and he invested in it an immense amount of psychic energy. That is partly why this great painting is so alarming: it is a symbol of van Gogh's inner centre. If you think about it, to come close to van Gogh would indeed be a frightening experience.

The room is claustrophobic, with those blue walls closing in on us and the floor tiles seeming to shoot like rockets towards the vanishing point with a dizzying sense of perspective. We are shut in by that back wall. There are two doors, both closed, and a window out of which we cannot look. There is a mirror that reflects nothing but chaos.

He has tried, pathetically, to enclose in this room all that matters most to him. On the right wall hang two paintings: one of himself, because he was a very self-centred man, though innocently so; the other of one of the rare people who befriended him, the local postman. Over the bed there is a weirdly tumultuous landscape that suggests his own mental state at times of disturbance. There are two rather indeterminate sketches (he was a passionate draughtsman) and there is a small wash-stand, almost quivering with electric power, held down by the sheer force of personal artistry. The towel hangs near it like a great flag drooping without wind, and there is the touching effort to impose order on his clothes: three sad little bundles neatly aligned.

The painful solitude is only emphasized by the two chairs, in awkward positions and with nobody to sit on them, and the double bed with its two pillows for one head. He thought of this bed as a great symbol of stability, yet it is a very strange bed, box-like, shutting up within it the wild animal of the scarlet quilt or blanket, which seems to be trying to escape from its imprisonment.

In this airless cell, van Gogh believed he was expressing great 'tranquillity and restfulness', as he wrote to his family. He is actually expressing intense anxiety and frustration, ordered, held in vigorous, trembling tension. It is this moving contrast that makes us feel close to him. We are an anxious, neurotic generation, and we warm to this neurotic man, struggling so bravely to impose calm upon the turmoil of his mental stresses.

Artist's Bedroom **Vincent van Gogh** 1888
Oil on canvas 72 × 90cm (28⅜ × 35⅜in)
Rijksmuseum Vincent van Gogh, Amsterdam, The Netherlands

Of all Rembrandts, this is the one that moves me most: the *Jewish Bride*. It has been given this title because, although nobody quite knows who this couple were, the exotic richness of their attire suggests the world of the Old Testament, hence 'Jewish'. 'Bride' has been added, perhaps unfairly since the man is as involved as the woman, from an attempt to express the view that this is a depiction not just of love but of married love. The couple are not young: their faces are worn and plain, but they stand together in an atmosphere of utter trust and mutual commitment.

To show an intangible such as 'commitment' is almost impossible, yet Rembrandt has achieved it. The man is not just laying a tender hand on his wife's breast, he is putting round her neck the expression of his love: his gift of a golden chain. She lays her hand assentingly upon his, accepting the gift, the gold, but fully aware that it is a chain. Shakespeare, meditating on this same mystery, wrote about love's inviolability:

> . . . Love is not love
> Which alters when it alteration finds,
> Or bends with the remover to remove.
> O no, it is an ever-fixed mark
> That looks on tempests and is never shaken . . .

We feel these two may have looked 'on tempests' but they have accepted that to love is to surrender freedom. It is a blissful surrender, but one of intense seriousness. The woman does not look up at her husband: she looks within, gently smiling, understanding the implications of the chain and freely taking upon herself the responsibilities of his happiness. She lays her right hand on her womb. He envelops her protectively, more obviously undertaking the same responsibility. They have deeply committed faces, quietly content to relinquish the freedom to choose different options and accept the adult freedom of total choice, which is the meaning of mature love.

The spiritual beauty of this is made visible by the radiant visual beauty of the actual painting, its thickened ridges of colour catching the light with the effect of glittering jewels. Recent restoration has made it clear that they are standing not in a familiar room but in a sort of architectural enclave, almost a dark cavern in which the only solid reality is their illusionless love for each other.

Jewish Bride **Rembrandt** c.1662–8
Oil on canvas 121.5 × 166.5cm (47$\frac{7}{8}$ × 65$\frac{1}{2}$in)
Rijksmuseum, Amsterdam, The Netherlands

This is a delightful picture by ter Borch, which used to be called the *Parental Admonition*. The girl's oyster satin shimmers as it cascades in the light, a focal point that makes it quite clear to us what is happening. Here is papa, finger raised reprovingly, telling off his erring daughter. There she stands, half-turned away, partly embarrassed, partly resentful, emotions we can all understand and feel an empathy with. Mama, of course, is distancing herself from the whole sorry business, pretending to be engrossed with her private thoughts.

This title held good all through Victorian times and up until the present. Everybody took an uncomplicated pleasure in the interior, with its rather vague furnishings and its clearly understood human centre. Then it began to strike viewers that the 'father' was strangely young to have such a grown-up daughter. The furniture was looked at more intently, and seemed to reveal itself as some sort of bed, with adjacent and appropriate trappings. Light began to dawn as people really started to look as opposed to glancing casually. It is true that the man is holding something on high, but it is not an admonishing finger. Careful scrutiny shows it to be a coin, which, together with the bed, the demure, elderly woman and the gorgeously attired girl, makes the scene read very differently. It is an unmistakable brothel scene, one of those glimpses into privacy (the 'interior') that so fascinated the seventeenth-century Dutch.

The 'interior' shows what goes on between people when they are not in public and on display. The 'mother' is the madam, waiting, sipping her wine in a ladylike fashion while the young people come to a financial agreement. The man is buying the girl's company. Obviously he has a great conceit of himself, with the extravagance of the sweeping feather on the hat and the fancy ruffles on his breeches. But notice that underneath the ruffles there is a rather unprepossessing trouser leg and sagging socks. There are ambiguities about this seemingly gallant young man, with his straggling hair and dull complexion. The girl is unproblematically exquisite as she ponders whether the fee is worth it. Is he offering enough, this vain and relatively unattractive man?

It is a sordid picture and it is left unresolved. We see the moment of tension, with the actual issue unclear. But the theme is blatantly clear, and the only comment is made by the sole moral actor in the drama: the dog, disgraced by human behaviour.

Parental Admonition **Gerard ter Borch** c.1654
Oil on canvas 71 × 73cm (28 × 28¾in)
Rijksmuseum, Amsterdam, The Netherlands

View of Delft

JOHANNES (JAN) VERMEER

Born Delft, The Netherlands 1632
Died Delft, The Netherlands 1675

Some people have said that this is the most beautiful painting in the world. And yet, what is it? It is just a view of Delft, Vermeer's home town. It is this, I think, that is the secret of the Vermeer magic: he takes something absolutely simple, something commonplace, and then he makes the light shine on it. It is not that the light makes it different but that at last we see it as it really is.

This painting is an almost photographic representation of the city of Delft but it is also something more. It is revealed as that interior city: the heavenly Jerusalem that we all long for and never reach. But for us to be able to see this blissful city, the Eden from which we have been exiled, we need (an absolute visual essential) to have that lower layer of sun-baked beach. We also need the river, a further layer of separation. Above these two layers rise two more: the stretch of the city itself, ideal and distant, and finally the great over-arching sky under which all exists.

We can only see the visionary place because we are not there, yet in a mysterious sense we are indeed there, because Vermeer has made it so specific for us. There is a specific time on the church clock: ten past seven. Light plays with glorious impartiality over the city buildings. It picks details at divine random: here a streak of blue on a boat in the harbour, there a wonderfully golden roof. Every brick seems to glitter in the early morning sunlight. It is the precise kind of over-brightness we get when a storm is coming, and we can in fact see the darkening clouds overhead. But the storm has not yet arrived, Delft still shines in the lucidity of the light. So everywhere we look, along the whole expanse of the view, we see both a real city and a magical city shining before us.

What is so interesting about Vermeer is that he never really has a 'story'. His leading actor, his 'hero', is always light itself, the wonder of it. This painting is perhaps the only one in which light finds its own subject, because it is light that creates this city, in its ideality and realism. We see what reality is, infinitely more than we imagined. That is why this is so profoundly tranquillizing a picture. We do not long with eager passion to cross the river to the visionary city. We look at it with gentle longing, with hope. Vermeer has set the city across a great river, but he has given us a boat.

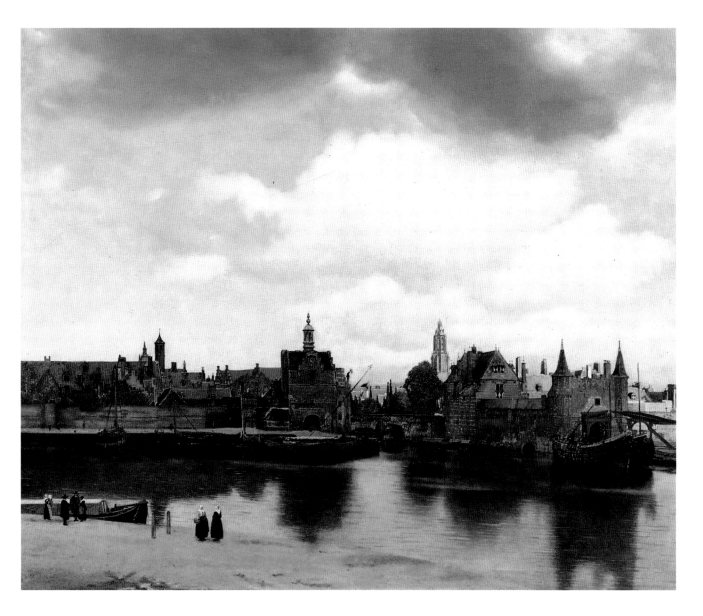

View of Delft **Johannes (Jan) Vermeer** c.1661
Oil on canvas 98.5 × 117.5cm ($38\frac{3}{4} × 46\frac{1}{4}$in)
Mauritshuis, The Hague, The Netherlands

What I love about Rembrandt is his refusal to romanticize and the way he unerringly puts his finger on psychological truths. The long relationship between Saul and David was one that could well have been romanticized, especially as the biblical events were familiar reading matter in Rembrandt's day and all the subtleties of interpretation would have been savoured. Saul was the king that God gave the Jews in response to their pleading; David was the hero who slew Goliath with his sling. Saul rewarded him, but their relationship was long and devious, and it ended with open warfare in which Saul self-destructed and David became king.

Rembrandt is focusing on an early and little studied aspect of their lives together, when Saul's mental instability gave rise to ungovernable rages in which he screamed and wept and hurled his spear at his attendants. In these wild fits, David could calm him down by playing the harp. Rembrandt contemplates David the musician, and sees him as scrawny, young and Jewish. This is not the magnificent David of the Renaissance but what Rembrandt thinks is more likely to have been true: an artistic, youthful harpist, lost in his music but still uneasily alert to what the king is doing.

Saul is shown sunk in all the wretched misery of the manic-depressive. He is wiping his terrifying face with his curtain because, great king though he was, he cannot pull himself together enough to draw out a handkerchief. He still has his dangerous spear, but his grasp is flaccid. We sense that he is gradually emerging from the horror of his condition, pacified by the music.

It is the contrast between the two – wholly without sentimentality – that fascinated Rembrandt. The old mad king fills his half of the canvas; he is present power, alarmingly unstable. The small king-to-be is only able to half-fill his part of the picture. Above him thickens a great hole of darkness, indicative, I think, of two things: one is the blackness that engulfs poor Saul, a darkness of spirit; the other is the future ahead for David, still innocent and vulnerable. He is destined to be king and fill the vacant space, but it will happen, as the contemporary viewers knew well, only in dark and agonizing ways.

Despite all the superficial grandeur, we are asked to ponder the painful reality of two human beings, struggling with their personal problems and their unknown destinies.

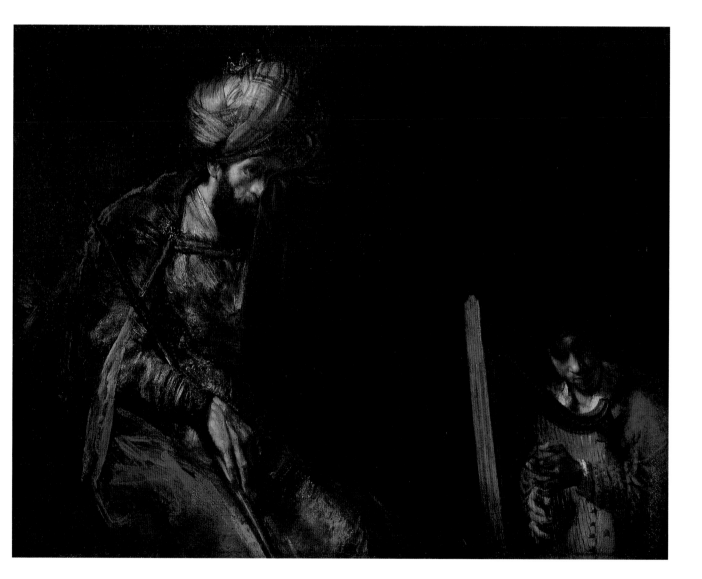

Saul and David **Rembrandt (attrib.)** c.1655
Oil on canvas 130 × 164.3cm ($51\frac{1}{8} \times 64\frac{5}{8}$in)
Mauritshuis, The Hague, The Netherlands

BRIEF LIVES
OF THE ARTISTS

Cristofano ALLORI (1577–1621)

A Florentine by birth, Allori is sometimes known by his family name of Bronzino. He was taught first by his father, Alessandro, then entered the studio of Gregorio Pagani, whose style he preferred to his father's. He visited Rome in 1610 where he saw Caravaggio's paintings. He was a perfectionist and by 1616 was very famous. Allori was a gifted man, a fine portrait painter, a landscape artist, poet and musician. Gossip reports him to have been a libertine who had bouts of piety, and it is true that he formed an unhappy and expensive liaison with a woman known as 'La Mazzafirra'. She was the model for his Judith, while the head she carries was said to be a self-portrait.

Albrecht ALTDORFER (c.1480–1538)

Born in Bavaria, Altdorfer spent most of his life in Regensburg, where he held several official posts and became prosperous. His life seems to have changed in about 1511 when he made a trip down the Danube and was moved by the scenery in the Austrian Alps. He made many landscape drawings and etchings, and his paintings gradually gave more and more importance to the landscape rather than the figures. In 1526 he was made city architect and became a member of the town council. Apparently, he was a happy man who had a successful career, but we only know the bare outlines of his life.

Fra ANGELICO (c.1400–1455)

Guido di Piero was born in the Mugello, north-east of Florence. Unlike many novices, he was apparently a mature man, as well as already being a recognized artist, when he joined the Dominican community in Fiesole, where in 1450 he was appointed Prior of San Domenico. The title Angelico seems to refer to his goodness as a monk as well as his genius as an artist. He became very well known, working outside Florence and Fiesole on a number of occasions, the most important being his invitation to work in Rome, where between about 1445 and 1449 he painted four cycles of frescos in the Vatican. He had studio assistants but was himself a fast worker. In about 1453 he returned to Rome where he was buried in the main Dominican church, Santa Maria sopra Minerva.

Hans BALDUNG (c.1484/6–1545)

Hans Baldung came from a family of lawyers and doctors in south-west Germany and at about eighteen he entered Dürer's workshop in Nuremberg as an apprentice. In 1509–10 he married, settled in Strasbourg and began his series of images of witches, as well as designing stained-glass windows and making woodcut illustrations for books. He was commissioned in 1512 to paint the important altarpiece in the cathedral at Freiburg, where he spent five years. The Reformation meant less demand for religious subjects and he turned to allegorical themes from classical literature. He was considered by his contemporaries to be one of the greatest painters of his time, and his drawings were acquired by early collectors.

Giovanni Lorenzo BERNINI (1598–1680)

Bernini is known as a great sculptor and architect, but he was the Renaissance all-rounder: he wrote music and comedies, made stage designs, and painted as well. Born in Naples, Bernini was first taught by his father, a sculptor. The family moved to Rome in 1605, where Bernini stayed all his life, apart from one visit to Paris in 1665. When he was still a teenager the wealthy Cardinal Scipione Borghese commissioned sculptures from him. But Pope Urban VIII was his most important patron, with whom he had a long working relationship. A devout Catholic, he believed he was the tool of God. He was said to be stern by nature, but passionate when angry, a profuse talker with strong convictions. It was as Architect of St Peter's that he became famous; for fifty-six years he was responsible for the major works in the Basilica. He employed numerous assistants in his studio, and most sculptors in Rome worked under him at some time.

Gerard ter BORCH (1617–1681)

Ter Borch was born in the eastern Netherlands. He was a precocious child and began his training under his father. When he was about fifteen it seems he studied painting in Amsterdam and then in Haarlem. He travelled to England in 1635 to join the studio of his uncle, who was an engraver, and two years later he went to Italy and Spain. He painted portraits with a rare psychological penetration, but his greatest skill was in depicting the Dutch interior and the small domestic dramas it enclosed. In 1654 he was in Deventer, where he stayed for the rest of his life.

Sandro BOTTICELLI (c.1445–1510)

Alessandro di Mariano Filipepi was born in Florence, the son of a tanner. The nickname Botticelli means 'a small wine cask', a name which seems to have first been given to his elder brother. He was a pupil of Fra Filippo Lippi and, after commissions in Florence from the Medici family, he was invited to Rome in 1481–2 to paint frescos in the Sistine Chapel. Botticelli's brother was a follower of the preacher Savonarola, who condemned works of art to his 'bonfire of vanities', and it seems Botticelli also became a follower about the time Savonarola was burned at the stake in 1498. He died, unmarried, in Florence and was buried in the church of Ognissanti.

Pieter BRUEGEL the Elder (c.1525/30–1569)

The details of Bruegel's life are shadowy, but it is now known that he was not a simple peasant, as traditionally assumed, and was instead a cultured man. Recent detective work has suggested he was born in what is now north-east Belgium. In that period the Netherlands (the modern country together with modern Belgium) was under Spanish rule. In 1551 he became a Master of the Antwerp Guild, and travelled to Italy and Switzerland. On his return to Antwerp he worked for an engraver and print-seller, and for the rest of his life he was both a painter and a designer of prints. He married the daughter of his old teacher in 1563 and the couple went to live in Brussels, where he died young, the last years of his life being shadowed by political and religious strife.

Hans BURGKMAIR (1473–1531)

The son of a painter, Burgkmair was born in Bavaria. He was a pupil of Martin Schongauer, then a famous painter and an important figure in the development of engraving. Burgkmair seems to have lived mainly in Augsburg, painting and engraving, and we know that he admired Dürer and that both artists made portraits of each other. But apart from scanty details, we know very little about his personal life: there are no 'biographical spectacles' through which to view his painting, which is no bad thing!

CARAVAGGIO (1571/2–1610)

Michelangelo Merisi da Caravaggio was the son of an architect, who died when he was young. At eleven he began his apprenticeship in Milan, and went to Rome in about 1592. After a difficult start he finally received a public commission in 1599; he caused a sensation with his radical interpretations of traditional subjects, his light effects and his insistence on painting directly from life. Increasingly aggressive, he got involved in a number of brawls, and his killing of a fellow-player in a ballgame caused him to leave Rome in 1606. He fled to Naples and then to Malta, where he was made a knight of the Order at the lowest grade, a state of grace that was, not unexpectedly, short-lived. After numerous escapades he ended up in Naples and was seriously wounded in a fight in a tavern. Ironically, he was mistakenly imprisoned and died whilst waiting for a papal pardon to arrive. His early death was greatly mourned and the effects of his genius are still with us.

Vittore CARPACCIO (c.1460/5–1525/6)

Apart from one possible trip to Rome, Carpaccio spent his life in Venice. He may have been a pupil of Gentile Bellini and was an assistant to Giovanni Bellini. He had a special gift for narrative cycles and had an enchanting command of detail. In the 1860s John Ruskin's enthusiasm for his work made people look again with fresh eyes. We know little about this enchanting artist and must simply delight in the work he left us.

Paul CÉZANNE (1839–1906)

Born in Aix-en-Provence to a wealthy family, Cézanne desperately wanted to become an artist, although his father intended him to be a lawyer and the art establishment in Paris thought him remarkably ham-handed. In Paris he entered into the revolutionary fervour of the time with his friend Émile Zola and also applied to the conservative Académie des Beaux Arts. He submitted work to the first Impressionist exhibitions in 1874 and 1877 but his style was not well received. On his father's death in 1886, Cézanne was able to retreat to Provence and devote himself to the revolutionary paintings which were to form the basis of twentieth-century art, though he himself always felt he was falling short. Like Titian and Rembrandt (both to whom he is equal in genius) his work grew all the more beautiful as he aged. He painted almost to the day he died.

CORREGGIO (c.1489–1534)

Antonio Allegri was known as Correggio from his birthplace near Modena, where he also died. He was traditionally a pupil of Mantegna and his early paintings certainly show his knowledge of Mantegna's work, although the style is softer. His greatest frescos, always much admired, are in the cupolas in St Giovanni Evangelista and the Cathedral in Parma. The events of his life seem to have made no mark on the world although his art grew and deepened. His death in his early forties was an irreparable loss.

DONATELLO (1386/7–1466)

Donato di Niccolò di Betto Bardi was born in Florence. He was described as a 'rare and simple man' whose sculpture was unrivalled. In 1403 he was an assistant to the Florentine artist Ghiberti, who had won the competition for the bronze doors of the Baptistery. Three years later he made statues for the Cathedral, and continued to work for it over the next thirty years. Brunelleschi was a friend, with whom he talked about the problems of art, but their friendship seems to have ended with a quarrel. He went to Rome in about 1431–3 to study antiquity, and enthusiastically dug up fragments of columns and capitals to measure and copy. In 1434 he was described as 'a man for whom the smallest meal is a large one, and who is content in every situation'. He moved to Padua in 1443, where he stayed for about ten years, finally dying in Florence, a poor man in a modest house.

Albrecht DÜRER (1471–1528)

Born in Nuremberg, Dürer was one of eighteen children. In 1490–4 his goldsmith father allowed his gifted son to make a prolonged aesthetic tour of Germany, before returning to Nuremberg to settle down. He made one or two trips to Italy and met the ageing Giovanni Bellini, which had an enormous impact on him. His success as a painter, his charm and sophistication as a man and the lessons he had learnt in Italy concerning the painter's importance, enabled him to transform the social standing of the German artist. Dürer remains the greatest and most influential of the Northern painters.

Artemisia GENTILESCHI (1593–1652/3)

A student of her father, the painter Orazio Gentileschi, Artemisia was also strongly influenced by Caravaggio's work, with its strong contrasts of light and shadow and rich colours. When she was nineteen she was raped by a fellow artist, Agostino Tassi, which led to a notorious trial in Rome. She married a Florentine after the trial but her reputation never totally recovered because of the incident. The marriage was brief and she led an independent life, unusual for women at that time, and travelled extensively. Between about 1638 and 1641 she was in London, where her father was working, but she mainly lived in Naples for about the last twenty years of her life. She remains the one undoubtedly major talent among women artists of the Renaissance and Baroque.

GIORGIONE (C.1477–1510)

Giorgio da Castelfranco was so-called after the town where he was born. He was an important figure in the evolution of Western painting but there are very few facts known about his life, except that he died young of the 'plague'. It seems he was called Giorgione ('Big George') because of the greatness of both his spirit and his size, but this, of course, is sheer guesswork. It seems somehow appropriate that this most curious of painters should elude our biographical curiosity.

Vincent van GOGH (1853–1890)

Van Gogh was a Dutchman, the son of a Protestant pastor. Not until 1880, having worked in art galleries in England and Holland, and after making an abortive attempt at becoming a pastor himself, did he decide to become a painter. He was helped by his younger brother Theo, whom he joined in Paris in 1886, but his pictures did not sell and in 1888 he moved to Arles. His mental balance was never assured: the most famous incident being when he cut off his ear in a moment of wild unhappiness. Harassed by the local inhabitants he entered the sanatorium at St Rémy as a voluntary patient, where Theo wrote to him that he had at last sold a picture. In May 1890 he moved to Auvers-sur-Oise near Paris, where the doctor was an artistic sympathiser. But van Gogh was too ill to be helped: on 27 July he borrowed a revolver and shot himself in the stomach. He died two days later, aged thirty-seven. Theo died six months later.

Francisco de GOYA (1746–1828)

Born in a poor village in Aragon, Goya grew up in Saragossa, where his father had a gilder's shop. In 1774, now married, he was called to Madrid to make cartoons for the Royal Manufactory of Tapestries, moving eventually to become Painter of the Royal Household, the startling truthfulness of his loyal portraiture apparently accepted without dismay. When he was forty-three he fell ill and became totally deaf. Isolated and despondent, he nevertheless began a brilliant period of work. He lived through the Napoleonic invasion of Spain, emerging battered but indomitable at the end. Finally, old and weak, with failing sight, he went to Bordeaux, where he stayed until his death. Reading his letters and the accounts left by his friends, we still cannot fathom the nature of this strange and wonderful artist.

El GRECO (1541–1614)

Born in Crete, Domenikos Theotokopoulos, El Greco ('the Greek') was mainly active in Spain. He trained in Crete, then a Venetian possession, as an icon painter and always showed the influence of Titian. El Greco came into his own when he settled in Toledo, Spain, in 1577 and the Spanish intelligentsia soon recognized his quality and began giving him regular commissions. The violent upheavals and intense spirituality of the Counter-Reformation fused with Greco's own affinity with Mannerist innovation to create his extraordinary style characterized by its distorted figures and strange, almost mystical, colours. As times changed, his circle of admirers diminished but there were always those who responded to his singularity of vision.

Hans HOLBEIN the Younger (1497/8–1543)

The son of a painter also called Hans, Holbein the Younger left Germany in 1514 to study in Basle, and there he stayed until he travelled through the Netherlands to England, armed with a recommendation to Sir Thomas More from Erasmus. He finally settled in London and became one of Henry VIII's official court painters. Ironically, this most civilized of men died of the plague.

Jean-Auguste-Dominique INGRES (1780–1867)

The son of a jobbing sculptor in south-west France, Ingres studied under David in Paris. There were always those who appreciated the purity of his graphic line, but he had a tempestuous career; sometimes admired, sometimes reviled. He turned away from contemporary Classicism and became a radical painter, with a passion for Raphael. He ended his days with great prestige, a supporter of the orthodoxy he had earlier rebelled against, but it may be doubted whether his later works have the power of his early masterpieces.

Jacob JORDAENS (1593–1678)

Jordaens was the son of a wealthy merchant and lived all his life in Antwerp, a successful member of the bourgeoisie, who were his main patrons. He had a long, productive career, though royal patrons only commissioned him after the death of Rubens (in 1640). His work has the 'feel' we associate with the Flemish: robust, good-humoured, rather stolid. We tend, therefore, to think of Jordaens himself as thus, but we may be completely mistaken.

Vassily KANDINSKY (1866–1944)

Often regarded as the 'founder' of abstract painting, Kandinsky was born in Moscow but mostly worked outside Russia, mainly because of lack of appreciation there. Initially a teacher of law, it was only when he was thirty that he decided to be a painter and moved to Munich to study and then teach (he was a natural teacher). Kandinsky wrote a great deal about his theories of art and explored the parallels between art and music, much influenced by theosophy. He became a professor at the Bauhaus, sharing a house with his friend Paul Klee, but after the Nazis closed the Bauhaus in 1933 he moved to Paris where he lived for the rest of his life. An instinctive aristocrat in life as well as in art, he was always hugely self confident.

Lorenzo LOTTO (1480–1556)

Lotto's strange and distinctive style attracted commissions from all over Italy. He may have trained with Giorgione and Titian under Giovanni and Gentile Bellini, but few details of his life are certain. Most of Lotto's work is religious in subject but always with a unique slant. He is not exactly subversive, but his interpretations are amongst the most personal in art history. This is perhaps most evident in his portraits. Towards the end of his life, Lotto became a lay brother in a monastery near Loreto, where he later died.

Édouard MANET (1832–1883)

Manet came from a Parisian family of well-to-do, high-minded public servants. He became a naval cadet, but after failing his examinations in 1849 he surprised his family by deciding to become a painter. In 1863 his submissions to the Salon were rejected; all the rejected works were exhibited elsewhere, and particular abuse was directed at *The Picnic*. The ridicule he received at the 1865 Salon made him briefly flee to Spain. Filled with self-doubt, though he hid this beneath a charming, well-bred manner, he was helped by his admirers, particularly Berthe Morisot. In 1873 he at last had a success at the Salon, and he was awarded the *Légion d'honneur* in 1881. He has been described as both a 'revolutionary' and as a '*sale bourgeois*', underlining the dichotomy in his own character: at the same time a conformist and an ardent left-winger.

Andrea MANTEGNA (1430/1–1506)

Born in the Paduan countryside, the son of a carpenter, Mantegna was apprenticed as a boy to Francesco Squarcione, a mediocre talent. In Padua Mantegna developed a love for the classical past of Italy. Squarcione used to adopt his most talented pupils so as not to pay for their work; Mantegna managed to free himself after a court case. When he was in his early twenties he married the sister of Giovanni and Gentile Bellini, and so joined a great Venetian dynasty of painters. At the age of thirty he moved with his family to Mantua where he remained for the rest of his life as a court artist to the Gonzaga family. There he acquired land and a title and built a house modelled on an ancient Roman villa, which he filled with antiquities. He had a passion for stone, a meticulous eye for detail and was one of the first to practise the technique of engraving. The security of his material circumstances set him free to develop his strange and personal artistic vision, at once vulnerable and fiercely protected.

Henri MATISSE (1869–1954)

Initially, Matisse studied law in Paris, and it was only the chance intervention of an illness and the need to convalesce that made him realize that he wanted to paint. In his early years there were financial problems and his father took a dim view of his 'unrespectable' occupation as a painter, but from 1904 his career was more assured. Light always affected Matisse profoundly and it was his visits to Morocco and a prolonged stay in Nice in the South of France that inspired some of his most beautiful paintings. Like Titian, he grew greater as he grew older, and, when he could no longer lift a brush, he created cut outs from coloured paper which have been of enormous and lasting influence.

MICHELANGELO (1475–1564)

Michelagniolo Buonarroti came from an old Florentine family. He was the second of five boys and was put to nurse with a marble-worker's wife. His mother died when he was six and his father remarried. Michelangelo was determined to be an artist from an early age, despite his father's opposition. At thirteen he began his studies under the painter Ghirlandaio, but he left to study sculpture in the Medici Garden. The papal court recognized his quality very early on and the rest of his life was divided between Rome and Florence, depending on the turbulent political climate or the commissions he received. He had a fiery relationship with Pope Julius II, and successive popes, not to mention the Medici. Very much against his will he accepted the commission to paint the ceiling of the Sistine Chapel in 1508–12, designing the scaffolding himself, and the *Last Judgement* there from 1536 to 1541. He was sculptor, painter and poet, and in his last years he was active as an architect and was Chief Architect to St Peter's.

Bartolomé Estebán MURILLO (1617–82)

The youngest of fourteen children, Murillo was born in Seville. He was orphaned early in life, which perhaps explains the pathos that suffuses much of his work. His professional career, however, was very successful and long-lasting, although his reputation has been increasingly diminished, and only now are we beginning to realize that he must not be judged by the emotional nature of his themes. We know little about him as a person, but the marvellous truthfulness of his response to material reality suggests – in the highly religious context of his work – a complex nature.

Nicolas POUSSIN (1594–1665)

Poussin, one of the very greatest of painters and certainly the most important French painter of the seventeenth century, actually spent his most productive years in Italy. As his reputation grew, he began to get important commissions, such as painting an altarpiece for St Peter's in Rome, and in 1640 he was summoned back to France by Louis XIII and Cardinal Richelieu. Although he was made Superintendent of the Academy, Poussin found the artistic climate in Paris stifling and returned to his beloved Rome in 1642 where he remained for the rest of his life. His vision of the landscape, profoundly intellectual while at the same time profoundly romantic, does not always have immediate appeal but there is no painter who more repays close study.

RAPHAEL (1483–1520)

Raffaello Santi, or Sanzio, was born in Urbino, one of the leading cultural centres in Italy. At the surprisingly young age of seventeen he was already a Master, increasing his artistic scope as he moved through Florence and on to Rome. Pope Julius II immediately recognized his supreme quality and there was general grief at his early and untimely death. Raphael had a unique gift for absorbing influences and going beyond them. His work is almost too perfect and is best appreciated in small doses.

REMBRANDT (1606–1669)

Rembrandt was a miller's son who left his home in Leyden to settle in Amsterdam. His personal life seems not to have been particularly happy or successful, and he died poor and lonely, but still richly creative to the end. Rembrandt's poverty was largely of his own making: he was wildly extravagant in buying art. The details of his life – all well-known – are somehow unimportant in comparison to the immense integrity and visual beauty of his work. He transcends fact in every respect, literally and artistically.

Sir Peter Paul RUBENS (1577–1640)

Rubens' career was an uninterrupted success from the time he left his birthplace, Siegen in Westphalia, and moved to Antwerp in 1589. Like many painters of the day, he subsequently went to Italy where the power and beauty of his work was fully recognized and in 1608 he was invited by the Spanish Governors of the Netherlands to return to Antwerp as court painter. Here, Rubens ran a vast studio and employed many assistants – including van Dyck – which meant that his engravings, and so his fame, spread across Europe. He won nearly all the prestigious commissions of his day, including painting the ceiling of Charles I's Banqueting House in Whitehall in London. He was also called upon by the government to act as a diplomat and negotiate treaties, which he did with great success. Rubens was a man of courtly demeanour, tact and great integrity who also had the bliss of an extremely happy private life. Four years after the death of his beloved first wife in 1626 he fell passionately in love with the 16-year-old Hélène Fourment and devoted much of his later life to her. Apart from gout, he seems to have died as happily as he lived, one of the rare instances of a completely blessed life.

TITIAN (c.1487–1576)

Born Tiziano Vecellio in Pieve di Cadore in the Italian Dolomites, Titian most likely served as an apprentice to both Gentile and Giovanni Bellini, but was perhaps most profoundly influenced by Giorgione. He was the only artist of the day who can be compared in stature to Michelangelo but whereas Michelangelo drew his strength from his association with the Papacy Titian – a much more worldly man – was the court painter to the Holy Roman Emperors. In 1532, Emperor Charles V commissioned him to paint his portrait and a unique relationship developed which continued into the reign of Charles's successor, Philip II of Spain. Titian died of the plague claiming to be 99 but scholars have continually revised his date of birth, assuming that he added a few years to his age in order to boost his prestige. Whatever his age, he constantly grew in artistic power. 'Late Titian' is an astonishingly beautiful period still not fully appreciated.

Diego VELÁZQUEZ (1599–1660)

Velázquez was born in Seville, but was early summoned to Madrid to paint a portrait of Philip IV, then eighteen. It was so successful that he was appointed Painter to the King and for the rest of his life worked in the King's service. It was said he was the only one allowed to paint Philip, and the two spent hours in conversation, which aroused some envy. He seems to have harboured dual ambitions: to become a great painter and to be publically acknowledged as a great gentleman. With the constant support of his royal friend, he finally succeeded in obtaining his knighthood, but it seems surprising that he sought this sort of social recognition when his success as a painter was so great. His personality eludes us, rather as does his art. No painter has ever surpassed him.

Johannes (Jan) VERMEER (1632–1675)

Little is known of Vermeer of Delft except that he was a Catholic, father of eleven children and strangely unsuccessful in his chosen profession as a painter. There were constant financial difficulties and his early death left his family destitute. He seems to have kept an inn, and perhaps the haunted and silent beauty of his work represents a necessary personal counterbalance to the hated noise of much of his existence.

Paolo VERONESE (1528–1588)

Known as Veronese because he was born in Verona, Paolo's family name was Spezapreda, literally 'stonecutter'. He spent nearly all his professional career in Venice and seems to have run a huge and productive workshop. He was a highly successful painter, his reputation known beyond the Alps, though not achieving the same kind of international status as Titian. Despite trouble with the Inquisition because of his freedom when handling religious themes, Veronese was a devout believer and a hard-working professional.

Antoine WATTEAU (1684–1721)

Watteau was the son of a roofer. He had little education and less money, and, what mattered more, very poor health. Yet despite suffering from tuberculosis, he painted visions of an enchanted world which impressed even the Académie Royale. When they accepted him, they paid him the great compliment of creating a new genre: *fêtes galantes*. He died too young to develop his theme, but what he has left us suffices. No other artist has ever captured his note of wistful gaiety, suffused with the yearning of a natural 'outsider' as it is.

PICTURE CREDITS

Page 17, 19, SCALA/Museo Nacional del Prado, Madrid; 21, © Museo Nacional del Prado, Madrid; 23, 25, 27, SCALA/Museo Nacional del Prado, Madrid; 31, SCALA/Museo del l'Opera del Duomo, Florence; 33, SCALA/Museo di San Marco, Florence; 35, SCALA/Galleria Palatina, Palozzo Pitti, Florence; 37, 39, SCALA/Galleria degli Uffizi, Florence; 43, 45, 47, SCALA/Galleria Borghese, Rome; 49, SCALA/S. Pietro, Vatican, Rome; 51, SCALA/S. Luigi dei Francesci, Rome; 53, SCALA/S. Maria del Popolo, Rome; 57, SCALA/Accademia, Venice; 59, SCALA/Scuola di S. Giorgio degli Schiavoni, Venice; 61, 63 SCALA/Accademia, Venice; 67, 69, 71, 73, 73, 76, 77, Kunsthistorisches Museum, Vienna; 81, 83, 85, 87, 89, SCALA/ The Hermitage Museum, St. Petersburg; 91, © ADAGP, Paris and DACS, London 1994; 95, 97, 99, 101, 103, Gemäldegalerie, Staatliche Museen Preussischer Kulturbesitz, Berlin; 107, 109, © photo R.M.N./Musée d'Orsay, Paris; 111, 113, 115, © photo R.M.N./Louvre, Paris; 117, SCALA/The Hermitage Museum, St. Petersburg/© Succession H. Matisse/DACS 1994; 121, 123, 125, Koninklijk Museum voor Schone Kunsten, Antwerp; 127, 129, Museum Mayer van den Bergh, Antwerp; 133, Vincent Van Gogh Foundation, Van Gogh Museum, Amsterdam; 135, 137, © Rijksmuseum-Stichting, Amsterdam; 139, Photograph © Mauritshuis, The Hague, Inv. No: 92; 141, Photograph © Mauritshuis, The Hague, Inv. No: 621.

INDEX